Random Access

*An anthology of contributions from
SOFA Friday Events series 1992/93,
Glasgow School of Art*

Random Access
On Crisis and its Metaphors

Edited by

PAVEL BÜCHLER

and

NIKOS PAPASTERGIADIS

 RIVERS ORAM PRESS

First published in 1995 by
Rivers Oram Press
144 Hemingford Road, London N1 1DE

Published in the USA by
Paul and Company
Post Office Box 442, Concord, MA 01742

Set in 10/13 pt Palatino by N-J Design Associates
and printed in Great Britain
by T.J. Press (Padstow) Ltd, Padstow, Cornwall

Designed by Lesley Stewart

British Library Cataloguing in Publication Data
A catalogue record for this book is available from the British Library

ISBN 1–85489–066–2
ISBN 1–85489–067–0 pbk

for the students

Contents

Introduction

First there was the desire for a random access: a curiosity for what occurs in that space between ignorance and recognition where the arbitrariness of our knowledge and the fixity of other horizons stimulate a search for 'something else'. The scene for this loosely coordinated set of collisions was the Glasgow Film Theatre, the Friday Event, a series of weekly public presentations organised by the School of Fine Art. When the speaking was done and some lingering thoughts were still to be found here and there,...a residual method, or some sort of generalised intent began to transpire. What emerged was a set of addresses that took up, departed from and returned to a number of common issues. We might call this common space 'our shared anxiety for sustaining work and belief' or, phrased more optimistically, the necessity to define starting points and contexts.

Then came the questions. How tight must be the connections that unify any collection of critical and creative responses to contemporary culture? What would be the parameters and axioms for the pedagogy of the 'postmodern' student of art? Is it possible to mount yet another intervention against the fluxes of the postmodern?

Questions must be asked selectively—and selectivity implies decisions. In this case, the criteria that policed inclusion and exclusion could only be situated at the level of rumour, gossip and availability. We were attempting to pull out moments that were already in circulation within a broad view of the cultural domain; our decisions were of necessity more the result of compounded omissions than the expression of an intent. We embraced these chance encounters, and in the constellation of events we hoped that the project as a whole could be justified by three forms of knowledge: the concentration offered by a specific event; the comparative perspective formed across the interstices of observation and reflection; and the cumulative transpiration of values and energy that comes with participation. The turn of phrases, the grain of voices, the stumbling nervousness, the pacing argumentation, or the witty response—these inexplicably subtle influences may be central to the ability to learn and to discover, that is to say, to continue working. To listen in an art school to diverse and contradictory arguments is perhaps, today, a way of going out to find inspiration. After all, with what rhythm and flow can the making of art, an exercise that just barely skims the surface of futility, nourish itself as it is also guided towards another destination? Without exchange we wither. The substance of communication may be an identification with what is close at hand, or it might be the result of those calculated guesses into the distance of the unknown. Either way, it has the dynamism of an oscillation, like a breath which is always somewhere between the inhalation and the exhalation.

Random Access is, then, an aspect of the pedagogic enterprise: an opportunity to reiterate the multiplicity of perspectives on 'common' concerns and questions which

underpinned the actuality of the weekly discussions. To give a sense of their scope, it is necessary to go beyond the contributions included here and to recall the absent voices.

The art critics Desa Philippi and Andrew Renton addressed the operational strategies of 'thinking art' for negotiating the multiple uncertainties of the post-modern—from the crisis of art's mimetic function, to the seeming impossibility of defining any functionality in art at all. Jochen Coldeway, the theorist and promoter of experimental film, offered an analysis of the emerging possibilities for critical intervention in the structures of the global regime of satellite television and electronic media. Annette Kuhn, another film theorist, examined the social and political fantasies of Aliens and Blade Runner, while the screening of The Most Beautiful Age, filmed at the Academy of Fine Art in Prague by the Czech director Jaroslav Papousek in 1968, presented a view of 'fantasy' and 'fiction' as the real-life socio-political realities. The Scottish poet Douglas Dunn and the composer James MacMillan gave performances that exemplified the importance of a local vernacular within the process of creative communication. From 'real life' to the tabloid scandal: the poverty of cultural fascination which confines disgust and revulsion to moral impropriety was staged in Stuart Brisley's eulogy to 'Camillagate' – no chance that this yawningly titillating soap opera may give an inch to a political cause.[1] The politics of nationalism was the theme for the rock musician and political activist, and at that time Rector of Glasgow University, Pat Kane as he grappled with the dilemma of the simulacra of autonomy and the inequity of the Union. The significance of visuality in the nationalist unconscious could be compared with the phantasmagoric representation of women in the

progression of Western culture. Marina Warner charted the passage from the legendary old wives' tales to the work of modern artists like Leonora Carrington, Meret Oppenheim and Paula Rego. The lecture of the art historian Pat Gilmour was balanced on another precarious mapping: 'From the sublime to the gorblimey', as she wove intricate connections between the American modern master Frank Stella and the Namibian printmaker John Muafangejo...

It is as accidental as it is inevitable that, cumulatively, these voices strike a dissonant chord. If, nonetheless, a dominant claim over a perceived crisis in contemporary culture transpires through the eclecticism of the spirit and content of the programme as a whole, it provides no more than a tenuous link among the diversity of arguments. In the absence of transcendental themes that would equip our responses, we felt a compulsion to adopt a more generalised outlook. Where themes once offered a certain security, sharpening polemics as they emphasised specific priorities and objectives that separated your allies from your opponents, there are no longer any clear-cut positions. The critical path is now barely defined. Without prior guidelines and guarantees we are increasingly forced to think on our feet: constantly re-evaluating the proximity of the absurd and the infinity of ideals

The randomness of *Random Access* is itself a reflection of the tangential observations and forced dogmas concerning all contemporary discourses of art—and, indeed, all critique of the determining cultural and political conditions of modernity

Crisis is neither a marker of the condition, nor a projection of outcomes; rather the crisis is constitutive of the very phenomenon of contemporary culture. Instead of

proclaiming a crisis in culture, we prefer to take it as given. The question shifts from the realm of 'if' to 'what sort of' crisis. Terry Eagleton sets out this level of investigation as he comments on how the supposedly neutral domain of culture has itself been subjected to scrutiny and contestation. Culture can no longer be seen as the elevated zone in which the contradictions of the political and the economic can be raised in order to be resolved. Dragging the concept of culture away from the clutches of romanticism, and rubbing it into the gritty materialism of everyday life, may heighten our insight into the false illusions upon which it was previously founded, while it also forces us to reconsider the position and validity of cultural criticism. The crisis in this culture, in Eagleton's account, is not found in a lack of voices but in the political contestation for accessing and controlling the institutional space of articulation. Crisis is defined in terms of the distance between the critic and the social, and this is witnessed through the increasing deferral of the moment of intervention.

The crisis *in* culture, or the culture *of* crisis, is a paradox that binds much of Peter Sloterdijk's writing. The cynical appropriation of the concept of crisis as the productive tool for the perpetuation of structural forms of domination has been the focal point of much of German Critical Theory. Consider the reassuring sighs of relief and the new-found levels of comfort for the culture industry when the new heading of crisis is introduced as a convenient substitute for the shabby, exhausted and outdated '...isms'. Implications that beg the reappraisal of the rules of the game, and not just the determination of winners and losers, are rarely an impediment to utilisation within the dynamics of the institutionalisation of dissent. Modernity prospers through its most dedicated critics. It

is by posing culture on the knife point of life and death that 'the will to maximisation' is stimulated. Delicately and deliberately, Sloterdijk argues, the European spirit is situated on the cusp of identification with its own otherness. Crisis is thus both formative and transformative, at the centre and yet banished to the margins of cultural identity.

Where Sloterdijk reaffirms as he problematises the definition of Europe within the global experiment of capitalism, John Stezaker—who in his 'Friday lecture' mapped the 'depoliticisation' within the New York art scene in the 1970s—is leading us in his visual essay to the point where the collapse of alternative visions of the social is linked to the sundering of the prior utopias. Through the metaphor of (what seems to be, in a strangely distorted perspective) a blank projection screen, the cynical, the ironic and the critical find a new configuration as the typology of 'black-and-white' binarisms begins to appear unreliable. Such negotiations of critical difference are poised by Stan Douglas as he reminds us of the paradigm of freedom in the 1960s' avant-garde jazz: a new-found expression for integration between experience, emotion, spirit and intellect. The performance of tangential ordering and contrapuntal structuring is visually reconstructed in another expression of nostalgia for the impossible unity with the other. The presence of the black artist not only questions who is the privileged seer of modernity and its futures but also reminds us of a revolutionary possibility that was never materialised.

The openness of the futures may yet prove to be as narrow as the interpretations of the past. Neil Ascherson asks the seemingly ridiculous question of 'what if the Nazis embraced the expressionistic mode of modernism as the official artistic idiom of the Third Reich', in order to test

the proposition that the West would in counter-response have valorised socialist realism. Between these two tantalising hypotheticals Ascherson swings forth the plausibility of not only how close 'we' came to vulgarity but also exposes the persistent crudity of the categories for appreciation. No hint of guarantee from barbarism is to be found in this culture. 'Where have all the fascists gone?' asks Colin McArthur, as he looks again at the way we look at the classics like *Casablanca*. The enchanting recollections and reproductions have seemingly effaced the political. From Woody Allen to Ninja Turtles, McArthur examines the making of a legend and notes that, as always, the Hollywood culture industry with all its manifold tentacles remembers the sentiment but forgets the struggle. McArthur reminds us of both the film's call for a stance against fascism and the general repression of politics in contemporary culture.

Time for some more Critical Theory, so 'round up the usual suspects'. Walter Benjamin once again features on the most wanted list, but Ian Hunt gives a sharp insight into the destiny that lurks in the wanting of Benjamin. Hunt contrasts Benjamin's sporadic but intensive reflections on time and tradition with contemporary anthropological understandings of 'qualitatively distinguishable times', a sacred time and a profane time. The fine identification with the delicacy of the philosopher's writing, the serious concern to bear his warning of the loss of the aura in the art of living with art, and even the routine acknowledgement that revolutionary politics and religion are not necessarily opposed—all this has not prevented a fatalistic disposition. Benjamin's heroisation as the vulnerable martyr and the attending exaggeration of his melancholic disposition has blurred the necessity to politicise the 'nowness' of history.

What is a metaphor other than the seeing of similarities in differences? How is classification possible without the perception of the thatness in this and the thisness in that? What is communication without the perspective of incongruity? How would language work without relating the unrelated? For Richard Wentworth, the bizarreness of the banal and the banality of the bizarre is not an excursus into exotica but the material for communication. The accidental encounters with everyday objects heighten not just the potential within the interpretative act but force us to reconsider the multiple levels of meanings embedded in those nearby objects—a celebration of what Wentworth calls, impromptu activity. 'It's hard to say where we learn to do these things but without spur of the moment mindless ingenuity the world wouldn't work.' *Random Access* starts to take on the functionality of *bricolage*. For Susan Hiller the metaphorical process is most radically extended in the representation of the differences between cultures and the borderlines between the word of reason and the dream of madness, the polarity between theory and experience, or between the textual and the visual. Throughout her text, Hiller provokes the questioning of the authority to interpret dreams.[2] Learning to speak across these divides in the politics of transnational visual culture is a relearning of the ethics of difference, which, as Colin Richards argues, have been all too often structured by the unconscious hierarchies of an apartheid. Examining the controversy that surrounded a recent photographic exhibition in South Africa, Richards argues that the body of the other can not be apprehended without undoing the binarisms of beauty and repulsion. Cultural difference is taken as a crucial test that inflects the putative freedom of representation. Helen Chadwick's imaging of sexuality which problematises the

stereotypically gendered perception of the body, and Simon Watney's political reading of the iconography and mythology of an epidemic linked to sexuality, both prompt us to put the brakes on the quick connections and false distinctions.

The politics of art are most potent when they subvert the thin weightlessness of literality by following the opaque suggestiveness of metaphor. Didacticism for all its flat and shallow transparency cannot compare with that other mode of connecting the unconnected. In the times of crisis, with all paths seemingly blocked forever, the ability to connect is crucial. Living through these critical days requires an inquisitiveness and a persistence which theory alone cannot provide; at these crossroads we must listen and look very hard. Metaphors are always there, to the living end, but some are more deadly than others.

Pavel Büchler and Nikos Papastergiadis

Notes

1 Brisley's performance consisted of reading the transcript of the alleged telephone conversation between Prince Charles and Camilla Parker Bowles, known to the media as the 'Camillagate' tape, published in a newspaper on the previous day. For this publication, the artist intended to transcribe the text line by line in reverse order, from the end to the beginning, with the instruction to reverse also the sequence of the typeset passages. For legal reasons, this project could not be realised here.

2 Hiller's discussion of the representation of dreams in art history and of the techniques of dream art was complemented by the screening of her video *Belshazzar's Feast*.

1
The Crisis of Contemporary Culture

TERRY EAGLETON

What is the nature of the crisis of culture? It is surely
coupled with a crisis of nationhood, for what after all
holds the nation together but culture? Not geography, to
be sure: you can be British in Hong Kong or Gibraltar;
and not just the political state either, since that some-
what anaemic unity has to be fleshed out in the lived
experience of a corporate form of life. But that corporate
national identity has now been thrown into question by a
number of factors: by the advent of a multinational capi-
talism which traverses national frontiers as casually as
The Waste Land; by the geopolitical transformations
through which the advanced nations are now swinging
their guns from facing eastwards to train them on the
south; by the impact of revolutionary nationalism on the
metropolitan centres; by the arrival, in the shape of
postmodernism, of a thoroughly cosmopolitan culture;
and by the presence of ethnic diversity in a deeply racist
society. In much of this there is, for shamelessly unrecon-
structed Marxists like myself, an intellectually pleasing
contradiction to be noted between base and super-
structure, as the logic of immigrant labour and global
capitalist integration finds itself at odds with the

spiritual imperatives of a traditionalist, parochial, post-imperial national culture.

None of this is irrelevant to the study of English, as Sir Arthur Quiller-Couch well knew. As he remarked in Cambridge in 1916:

> Few in this room, are old enough to remember the shock of awed surmise which fell on young minds presented, in the late '70s or early '80s of the last century, with Freeman's *Norman Conquest* or Green's *Short History of the English People*, in which, as though parting clouds of darkness, we beheld our ancestry, literary as well as political, radiantly legitimised.[1]

The study of English was from the outset all about the legitimacy of national origins, all to do with the unspeakable anxiety that you might turn out as a nation to be something of a bastard. Hitching the study of modern English to the rude manly vigour of the Anglo-Saxons was one way of laying claim to such a suitably authorising heritage, though it posed a problem too: did we really want to be as rude, hairy and vigorous as all that? As one early opponent of English at Oxford put it:

> An English school will grow up, nourishing our language not from the humanity of the Greeks and Romans but from the savagery of the Goths and Anglo-Saxons. We are about to reverse the Renaissance.[2]

'Ethnicity' was not drafted into English by the polytechnics; it was of the essence from the beginning. English first germinates in Victorian England as part of a deeply racialised ethnology, and its immediate forebear is a comparative philology which seeks in language the evolutionary laws of racial or national *Geist*. If, for Oxford students

today, so-called Old English is compulsory; but a systematic reflection on what it means to read is not, this is a direct consequence of the racism and chauvinism of our forefathers. 'I would like to get up a team of a hundred professors', commented Oxford's Sir Walter Raleigh, with the civilised humanism which was to become the hallmark of his subject, 'and challenge a hundred Boche professors. Their deaths would be a benefit to the human race.'[3] And Raleigh was a good deal more liberal-minded than almost any of his colleagues.

Confronted in the early decades of this century by the challenge of a cosmopolitan modernism, English responded with the *ersatz* internationalism of Empire, at once global in reach and securely nation-centred. The writ of the English language ran all the way from Kerry to Kuala Lumpur; yet this confident hegemony contained the seeds of its own deconstruction. For it was characteristic of the Leavisian ideology of English, at least, to discern a peculiarly intimate relation between a certain richly resourceful use of the national language, and a certain uniquely English mode of experiencing; and from this viewpoint *Finnegans Wake* was entirely unthinkable even though it actually happened.

Such colonial or post-colonial writing drives a dangerous wedge between signifier and signified, dislocating the nation's speech from its identity. You can, of course, try to take care of all this by some such absurdity as 'Commonwealth literature', or by its later, theoretically more sophisticated mutation, 'Third World studies', which is today not even arithmetically accurate; but the embarrassing truth remains that there is now apparently a plurality of discourses of the human, and since the human is by definition a singular essence this cannot actually be so.

It is surely for this reason that literature—that esoteric pursuit of a few thousand not politically very important people like ourselves—has become in our time so curiously politicised. For there is no doubt that for the first time since the late 1960s, the so-called humanities, of which literary studies have been traditionally the flagship, have come in the West to provide an arena of intensive political contestation; and though this is in part a discursive displacement depressingly typical of our times, it is none the less testimony to the fact that the crisis which we are enduring is of a peculiarly cultural kind.

Nobody beyond academia cares very much whether we talk about signifiers rather than symbols, or codes rather than conventions; it is not for these sorts of reasons that literature has become important, or that there has been so much blood on the Senior Common Room floors. If literature is important today, it is because it is held to incarnate, in peculiarly graphic and sensuous form, the fundamental, universal language of humanity, at a moment when the regimes under which we live have need of that notion but have themselves rendered it profoundly problematical. Literature provides our most intimate, subtly affective acquaintance with that tongue, and so is the concrete correlate of that abstract political unity which we share as formally equal citizens of the state. I should confess in parenthesis here that I too believe in a common humanity, but that as a socialist I regard it less as an intuitive given than as a political task still to be undertaken. But for those who do not hold that view, the current challenge to this particular ideology of literature is understandably alarming. For many of them have long ceased to identify much of value in social life in general; and if the aesthetic cannot articulate that value, then

14 TERRY EAGLETON

where else, in a progressively degraded society, is there to go? If the materialists can get their grubby paws even on that, then the game is surely up. It is no doubt for this reason that the infighting over something as apparently abstruse as literary theory has been so symptomatically virulent; for what we are really speaking of here is the death of civilization as we know it. What is at stake in these contentions is nothing less than the devastating historical irony by which the advanced capitalist system has come steadily to undermine its own metaphysical rationales. And this is a good deal more serious than the question of whether *jouissance* or utter tedium is the most appropriate way to describe our response to *The Battle of Maldon*.

Like many human societies to date, capitalist regimes need to underwrite their activities by some appeal to transcendental value but, as Jürgen Habermas has argued, it is in the nature of such rationalising, secularising social orders to bring their own metaphysical foundations into increasing discredit, disenchanting with the one hand what they mystify with the other. In this sense too, base and superstructure, commodity production and spiritual legitimation, are embarrassingly at odds. Shakespeare still embodies timeless value; it is just that you cannot produce his stuff without the sponsorship of Smith and Jones Insurance. Postmodernism, taking its cue from its mentor Friedrich Nietzsche, offers an audacious way out of this impasse: forget about ontological grounds and metaphysical sanctions, acknowledge that God—or the superstructure—is dead, and simply generate up your values from what you actually do, from that infinitely proliferating network of conflict domination to which Nietzsche gives the name of will to power. Such a strategy promises to overcome the performative contradictions of

advanced capitalism—the disabling discrepancies between fact and value, rhetoric and reality, what we actually do and what we say that we do, which are themselves a source of ideological instability. But it exacts an enormous cost, which these social orders are quite properly too prudent to pay: it asks them to forget that the role of culture is not only to *reflect* social practice, but to *legitimate* it. Culture must not simply generate itself up from what we do, for if it does we will end up with all the worst kinds of values. It must also idealise those practices, lend them some metaphysical support; but the more the commodity form levels all hierarchies of value, mixes diverse life-forms promiscuously together and strikes all transcendence empty, the more these societies will come to deplete the very symbolic resources necessary for their own ideological authority.

This contradiction can be seen at almost every level of contemporary social life. If you erode people's sense of corporate identity, reducing their common history to the eternal now of consumerist desire, they will simply cease to operate effectively as responsible citizens; and so you will have to manufacture that corporate identity synthetically, in the shape of the heritage industry or imperial war. If you allow education to be invaded by the levelling, fragmenting commodity form, you will need all the more stridently to insist on basics, fixed canons, immutable standards. The more you commercialise the media, the more you will feel the need for poems that rhyme and say nice things about Lord Nelson. The more cheap black labour-power you exploit, the more you will feel inspired to preserve the unity and purity of the national culture. In all these ways, anarchy and autocracy, money and metaphysics, exchange value and absolute value, are both strangers and brothers, sworn foes and intimate bed-

fellows. So it is that the intellectuals of the New Right, having actively colluded with forms of politics which drain purpose and value from social life, then turn their horror-stricken countenances on the very devastated social landscape they themselves have helped to create, and mourn the loss of absolute value. It would help in this respect of course if they could surmount their clerkly scepticism long enough to get to the baptismal font; but since most of them cannot, whatever their secret hankerings, they must make do instead with that familiar surrogate for religion known as culture.

What has happened is that culture is less and less able to fulfil its classical role of reconciliation—a role, indeed, on which English studies in this society were actually founded. And this is so for a quite evident reason. For as long as the conflicts which such a notion of culture sought to mediate were of a material kind—wars, class struggle, social inequities—the concept of culture as a higher harmonisation of our sublunary squabbles could just retain thin plausibility. But as soon as such contentions become themselves of a cultural kind, this project becomes much less persuasive. For culture is now palpably part of the problem rather than the solution; it is the very medium in which battle is engaged, rather than some Olympian terrain on which our differences can be recomposed. It is bad news for this traditional concept of culture that the conflicts which have dominated the political agenda for the past couple of decades--ethnic, sexual, revolutionary nationalist—have been precisely ones in which questions of language, value, identity, and experience have been to the fore. For these political currents, culture is that which refuses or reinforces, celebrates or intimidates, defines or denies; it is brandished as precious weapon or spurned as insolent imposition, cherished as a badge of identity or

resisted as that which can do no more than tell you that you don't belong, never did and never will. And all this is surely strange, because culture is not only supposed to be innocent of power: it is the very antithesis of it. Somewhere between Shelley and Tennyson, the poetic and the political, the aesthetic and the institutional, were reconstituted as one another's opposite, as the intimate affective depths of the former became intuitively hostile to the rebarbative abstractions of the latter. Which is to say that one way of theoretically constructing literature came to be at odds with another. In the altercations between Burke and Paine, critics and intellectuals; Englishness and Continentality, the lyrical Donne and the revolutionary Milton, sensuous intuition and a central human wisdom won the day; and this thoroughly alienated theory of writing, now styled as the spontaneous certainties of the human heart, was then ready to do battle with an antagonist known as Theory, which like all such oppositional creeds lacked the conservative's privilege of not having to name himself.

What is subverting traditional culture, however, is not the Left but the Right—not the critics of the system, but the custodians of it. As Bertolt Brecht once remarked, it is capitalism that is radical, not communism. Revolution, his colleague Walter Benjamin added, is not a runaway train but the application of the emergency brake. It is capitalism which pitches every value into question, dissolves familiar life-forms, melts all that is solid into air or soap opera; but it cannot easily withstand the human anxiety, nostalgia and deracination which such perpetual revolution brings in its wake, and has need of something called culture, which it has just been busy undermining, to take care of it. It is in the logic of late capitalism to breed a more fragmentary, eclectic, demotic, cosmopolitan culture

than anything dreamt of by Matthew Arnold—a culture which is then a living scandal to its own firmly Arnoldian premises. Postmodernism then simply inverts this contradiction, seeking to undo the metaphysical, monological aspects of the system with something of its own heterogeneity. At its most callow, such theories complacently underwrite the commodity form, and do so in the name of an opposition to elitism. Nothing could in fact be more offensively elitist, more aloofly academicist, than this cynical celebration of the market-place, which for ordinary men and women has meant homelessness and unemployment rather than random libidinal intensities, and which globally speaking means war as well as cosmopolitan cuisine. Such 'radicalism', one might claim, deserves the reactionaries it drives to apoplexy, the one engendering the other in some stalled dialectic. What concerns the reactionaries is not random libidinal intensities, which they would not recognise at a distance of ten yards, but the supposed erosion of cultural standards; and nowhere is that assumed declension more evident than in language, which is another reason why literary studies have shifted to the eye of the political storm. 'Language is fascist', remarked Roland Barthes, in one of those extravagant hyperboles for which we all loved him; and though it is not of course true, what is undoubtedly true is that linguistic purity is the last refuge of the paranoid and pathological, the visceral, proto-fascist fantasy of those who feel undermined in their very being by the polyglot social order they themselves have helped to fashion. For language lies at the root of human identity, and to tamper with that is either poetry or treason.

The presumed decline in cultural standards can of course be traced back at least as far as Samuel Johnson, and perhaps to the Book of Exodus. No doubt the

Assyrians worried about the brevity of their adolescents' attention span, and the Phoenicians lost sleep over poor spelling. We should, I think, give no comfort to those who in the name of a fashionable anti-elitism would ignore real evidence of cultural deprivation; though we should remember of course that there is no single index of cultural flourishing or decline. But the Conservative government's plans for remedying what it sees as the inadequate state of English studies in British schools rest on a drastically mechanistic understanding of the subject and, if implemented, will do serious damage to the moral and social development of school students. If the government goes ahead with its philistine, ill-informed proposals, it will produce a generation of grammatically competent children without a creative idea in their heads. We are dealing here with ideologues for whom language is essentially an elocutionary affair, poetry a kind of metrical patriotism and English literature a semantic Stonehenge. Indeed one wonders why they don't surrender the teaching of English wholesale into the hands of the National Trust. Grammar and spelling are of course part of the material groundwork of social communication, and I know of no English schoolteacher who would disagree; but it is one thing to insist on competence in these areas, and quite another to betray a marked hostility to regional, ethnic, and working-class forms of speech, which can only injure the self-esteem of children who already feel rejected. All bureaucrats fear creativity, which is why the government wants to police and centralise the teaching of a subject vitally concerned with exploration; and if we allow it to succeed, it will simply clone our children in its own bloodless and boring image.

I have spoken of a crisis of culture; but the dangers we confront run a good deal deeper. For men and women do

not live by culture alone; and in the narrower sense of the term the great majority of them do not live by it at all. Radical cultural theorists have many faults, but megalomania is unlikely to be among them: it belongs to our very materialism to believe that, in any profound process of social change, we are not likely to be positioned at the centre. It is not the question of whether Alice Walker is greater than Thomas Mann which Washington is weighing up; it is weighing up whether the devastation wreaked by the collapse of the Soviet bloc will permit it easy pickings, or unleash forces which might dangerously destabilise its global rule. It is also watching to see whether the erstwhile post-capitalist nations will prove in the long run reliable partners in the enterprise of subjugating the South, or whether their traumatic insertion into world capitalism will prove so disruptive that they too must be kept constantly under the gun. None of this has much to do with the literary canon; but though culture is by no means central to these matters, it is not simply peripheral either. For the study of human culture addresses itself to the question of how these world-historical issues shape up in lived experience, how they pass through the defiles of the signifier to emerge as symbolic meaning; and to this extent the study of culture concerns itself with what is most distinctive about humanity, if not with what is most crucial to its survival and well-being. Culture can be defined in one sense as that which is surplus, excessive, beyond the strict material measure; but that capacity for self-transgression and self-transcendence is precisely the measure of our humanity.

This is not, curiously enough, how they view the matter in Downing Street. The problem for them is not, as they like to proclaim, that there is too little culture around, but that there is a risk of there being too much.

There is a real danger, in short, of producing a population with reasonably high cultural expectations in a society which cannot even provide them with employment. And since this is a classic for political disaffection, we may be sure that the government's more clairvoyant commissars are already bending its ear about the undesirability of educating the young beyond their station. No government can afford its people to be at once idle and well educated; and if it can do little about the former, given a grave economic crisis of the system under which we live, then it is highly probable that it will try even more strenuously than it has already to do something about the latter. We will be thrown back to that condition, elegiacally recollected by our reactionaries, in which culture will once again be the preserve of the elite, while a vocationalism without vocations will be the destiny of the people.

But it is the past, as well as the future, which radicals seek to protect; for, as Walter Benjamin remarked, not even that will be safe from the enemy if he wins. Benjamin's habit was to look backwards rather than forwards, finding a desirable future already dimly adumbrated in the hopes of those oppressed ancestors whose projects of emancipation had been crushed in their own time. 'It is not', as he comments, dreams of liberated grandchildren which stir men and women to revolt, but memories of enslaved ancestors.' And those who do not remember are, as Freud warned us, compelled to repeat. If radicals do not succeed in their current endeavours, then it is not only our progeny who will suffer the consequences; it is also those men and women who stood for generations outside the locked gates of the University, and dreamed fruitlessly of a condition in which culture might be available for all. If we fail, then we fail them too, freezing them in eternal unfulfillment. Looking back-

wards is second nature to our system; it is about time that it found a way of doing so, examining the exclusions on which it was historically built, which would be a way of moving towards a more just and rational future.

Notes

1 Quoted by Stefan Collini, 'Genealogies of Englishness: Literary History and Cultural Criticism in Modern Britain' in Ciaran Brady (ed.), *Ideology and the Historians*, Dublin, 1991, p.247.
2 Quoted by Chris Baldick, *The Social Mission of English Criticism*, Oxford, 1983, p.74.
3 Ibid., pp.88–9.

2
Untitled

JOHN STEZAKER

3

World Markets and Secluded Spots
On the Position of the European Regions in the World-experiment of Capital

PETER SLOTERDIJK

Capitalism as Permanent Revolution

The dynamic character of the modern world has rarely been expressed with such clarity and perceptiveness as in the following sentences from a classic nineteenth century writer who has been all but forgotten today:

> The bourgeois epoch is distinguished from all earlier ones by the constant revolutionising of production, continual disruption of all social conditions, perpetual uncertainty and turmoil. All fixed, rigidified relations with their train of ancient and venerable prejudices and opinions are swept away, all new-formed ones become antiquated before they can ossify. Everything that is solid and permanent melts into thin air, all that is sacred is profaned, and people are finally compelled to face up to the reality of their position in life and their relations with their fellow men.[1]

In 1848, Karl Marx defined the essential characteristic of the approaching epoch: 'continuous revolution'. Following Marx, the quintessential modern age has come to be regarded as the age of revolution. Since the eighteenth century, the term 'revolution' no longer refers simply to

the rotation of the planets, nor simply to political over-throw or a change of leadership. It has come to be used, increasingly, to describe the mode of being of a society totally dedicated to the idea of mobilising and renewing the world according to the laws of universal production and marketing. Seen in this light, the bourgeoisie, per-ceived as the restless centre of the definitive production—and enterprise—driven society, resembles a successfully expansionist Trotskyist world party—in so far as 'perma-nent revolution' has been the maxim of Trotskyism. For Marx, mankind in the bourgeois age fulfils the historically necessary role of acting as the gravediggers of all feudal relations.

Ruthless as a matter of principle, and justified by the natural law of benevolent egotism, the bourgeoisie obliterated every internal and external trace of monarchy and patriarchy, dissolved traditional attachments to the land, eradicated the idiocy of rural life and urbanised society; and in the psyche of the producers they replaced obedience, moderation and loyalty with enterprise, ambi-tion and consumerism. The great revolution overturned the old order of things, touching even the depths of per-sonality as it transformed masses of conscientious savers and conservers into frivolous borrowers and end con-sumers. This is why, from a psycho-historical and ideo-logical perspective, the ages of permanent capitalist revo-lution are characterised by progressive disillusionment; when people are forced, ultimately, to face up to the real-ity of their relations with their fellow human beings, they realise, too, that they will not be able to tolerate this new state of sobriety. It is no coincidence that drug dealing has become the hidden paradigm of the free market economy. Consumerist democracy is a system of discrete addictions behind which lies a brutally sober nihilism. You could say

that the meaning of the statement, 'everything solid and permanent melts into thin air', has only been fully realised with the ruthless and total mobilisation of the consumer and information society.

Victorious capitalism itself, with its advances in the industrial, urban, kinetic and information sectors, was and continues to be the first and last International, and Marx, its most important analyst, defined the adventure of modernisation both prophetically and pragmatically when he coined the term 'continuous revolution'. It was Marx too, albeit with a certain degree of reluctance, who exposed the reactionary nature of socialist anti-capitalism. Any form of socialism with claims to being anything other than the continuation of capitalism by improved means would render itself untenable as a form of counterrevolution—untenable because its every failure to keep pace with the most advanced productivity in competing systems (regardless of the ideological gloss put upon it) immediately forces it to turn upon itself. As Mikhail Gorbachev very rightly said, life punishes those who arrive too late. For more than half a century, the Soviet Union, in fact, indulged a costly semi-revolutionary, perhaps even a counter-revolutionary experiment, which has resulted in depression and delayed development of incredible proportions.

The pilot nations of the continually advancing West, on the other hand, which exist at the cutting edge of the permanent revolution cannot, by definition, arrive too late. Their being part of the revolution itself means precisely that they operate at the heart of the age, and, from that vantage point, decide how the world's clocks are to be set. Any analysis of the current structure of the world will have to pay much greater attention in the future to the glaring disparity between revolutionary and conservative

points on the economic space-time continuum, beyond the frame of reference represented by economic development policy. It is no longer sufficient to say: Russian watches are set to a different time—or Spanish watches, Austrian watches, Indonesian watches. We are beginning to see that the globalisation of the world through trade and the international debt system is forcing the world into a tragic totality, and that a significant proportion of international crises have their origin in an attempt to force all the peoples of the earth to conform to the GMT of capitalism. For the majority, this can only lead to the resentful realisation that they may well have the same watches, but only use them to calculate the hopeless extent to which they have fallen behind.

If we were to take a wide perspective on the current world situation, it would be appropriate for metaphorical and other reasons to imagine ourselves in the lobby of an international hotel where there is a board showing the guests the time in Singapore, Tokyo, Moscow, London, New York, San Francisco and Sydney. But instead of a board that shows the times in world capitals (however interesting this might be for pilots, diplomats and stock market dealers), let us imagine a historical clock that shows the points in the evolutionary or revolutionary calendar at which various areas of the world find themselves at the end of this century. Here we are particularly interested in the position of countries and cultures on the edge of the eye of the capitalist storm, who are looking for an answer to the crucial question, whether it would be wise for them to become more closely involved in the nuclear processes of the permanent revolution. A perspective of this kind has the advantage of distancing us from the hypocrisy of politicians who proclaim through every medium (especially in France and Germany) that a

two-speed Europe is out of the question as far as they are concerned; in fact, as any tourist can see, we are living in a three-speed Europe—in the midst of a four- or five-speed world.

On the 'Return of History' to the Centre of Europe

Observers of the train of events since 1989, which have so dramatically changed the face of Eastern Europe and the whole world, have drawn two conclusions from what has happened. The collapse of the Soviet Union—the 'divine surprise' of our century—exposed the hitherto unrecognised frailness of a system one had been prepared to regard as monolithic and determinedly self-assertive. The Soviet complex could, in fact, have remained in power for another decade, a generation, a century, but for the growing realisation in the minds of its leaders that the Soviet socialist project was a lost cause. What we now have to recognise is that this phenomenon, the crumbling Eastern empire, exemplifies an essential structural feature of the modern world—one which is common to our own as well as to the American system; I am referring to the fact that almost every aspect of life has been subsumed to the form of an experiment.[2] I would argue that the collapse of the Soviet Union does not, in any way, imply the defeat of experimental modernism and hypothetical progressivism; the bankruptcy of the Soviet Union is, rather, a positive expression of the advanced experimentalism embodied in the unfolding history of the modern age in Europe. The possibility of failure is, in itself, proof of the rational and modern nature of the experiment which is in the process of being wound up. One could regard it as the delayed victory of falsifiability over the theology of

history, of the experimental spirit over a sense of mission.

The second issue which close observers of the post-Soviet era have been forced to confront concerns the role of Europe in the context of what is commonly referred to as the superpowers. This issue will certainly prove to be the more difficult to deal with so it should come as no surprise that its assimilation has been accompanied by distortions and false notes.

Since the fall of the Berlin wall and the removal of the last red flag from the Kremlin, it has become common among commentators in Western Europe to discuss, initially with some embarrassment, then with increasing brazenness (or bluntness, at any rate), the prospect of Europe's return to the forefront of world politics. Those with fewer inhibitions air their speculations on the prospect of a new Berlin-Tokyo axis and hint that the losers of the Second World War will finally be successful in exacting economic revenge.[3] These lascivious rumours are lent substance by the fact that the collapse of the so-called Eastern bloc of the post-war era has also brought to an end the division of the world that followed Yalta. We are now living in a global context which is absolutely not that of a post-war era—however artificially extended this may have been in the East. Happiness is certainly not a recognised category of political life—but you know what some writers mean when they say that the happiest moment our generation has experienced was the ending of confrontation between the superpowers. Having witnessed such a momentous event, one can understand why some historians have echoed Goethe's words on the occasion of the cannonade at Valmy which saved the French Revolution: 'Today sees the birth of a new epoch in the history of the world, and you can say that you were there to see it.' After 1989, as even a cursory view of

events will confirm, the era of polarisation which had reduced the political map to little more than a paranoid comic strip was brought to an end. This led to the rediscovery of that minimum of complexity in international relations which any no-nonsense account of the actual situation ought to have recognised even prior to 1989—as, for example, in Henry Kissinger's pentarchical model or in the seven spheres theory propounded by the global sociologist, Johan Galtung.

For Europeans, of course, the disentangling of the superpowers has wider implications than merely serving to enhance their sense of these complexities: since 1989, they find themselves on a course which leads them back, inevitably, to questions of accidental identity. Willingly or otherwise, they will have to pay back the 'losers' bonus' which enabled them to adopt a humble role between the superpowers of East and West for almost half a century. Future assessments of the period 1945 to 1989 may come to regard it as a kind of political dream-time in Europe— an era of curtailed ambition and semi-responsibility, an age of understatement and indecisive waiting for something or other. Looking through various accounts of world history since 1945, one is struck by the unanimity of historians in regarding the decentralisation of Europe as the major consequence of the thirty-one years' war from 1914 to 1945 (which became a world war through the involvement of the USA).[4] One senses, at times, almost a feeling of relief at the realisation that history's centre of gravity has moved from the Old World (as Europe, with a certain relish, now describes itself) towards America and Russia, where world-shaking ideas and world-threatening weapons are stationed. It sounds, at times, as if European writers were welcoming the decommissioning of a dangerous reactor on their

territory. If, however, that explosive high technology called global politics continues to be controlled by optimistic barbarians across the Atlantic or by fatalistic Russians on either side of the Urals, we Europeans will pretend for as long as possible that small really is beautiful, and that having no concept whatsoever for the world as a whole is, in fact, a virtue. For almost four decades Europeans managed to slip comfortably into the role of sleeping partner in the West—apart from a few solo performances by the French; no one between Rome and Brussels took offence at references to the Economic Community which described it as an economic giant behaving like a political dwarf.

One of the positive, albeit perilous, consequences of the East European implosion of 1989 (no writer with any sense of the historical connotations of language would describe those events as a 'revolution') is that the more enlightened of the Europeans now find themselves forced to re-learn their role on the world stage. At future rehearsals, it may prove useful to recall a cultural definition of Europe which precluded from the outset any attempt to evade responsibility by escaping into smallness, political tameness and lack of global direction. I am not referring to the controversial concept of General de Gaulle, who never tired of talking about a Europe stretching 'from the Atlantic to the Urals'; regardless of the depth of the Gaulliste world-view it embodied, this concept was remarkable in so far as it expressed a refusal to conform to the global plan of the Cold War. Nor am I referring to Carl Friedrich von Weizsäcker's observation that Europe reaches from San Francisco to Vladivostock— a statement which makes us sit up and take notice above all because it uses quasi-cultural, geopolitical language to suggest the world-civilising nature of Europeanism.

Instead of such wide-ranging definitions, I would like to offer the following quotation from Paul Valéry, who, I believe, formulated a principle for the modernisation of Europe which is still valid. As one would expect, Valéry's theorem is a psycho-political definition of Europe as process and intensity:

> Wherever the European spirit is dominant, there you will find desires at their maximum, maximum work, maximum capital, maximum return on investment, maximum ambition, maximum power, maximum alteration of the environment, relations and interchange at their maximum. It is this aggregation of maximised potential that comprises Europe....It is remarkable that the European is not defined in terms of race, nor by virtue of language and custom, but in terms of the desires and range of his will.
> (*La crise de l'esprit*)

A quasi-mathematical and systematical formulation such as this enables one to distance oneself from clichés about the European 'economic miracle' after 1945 and from the excitable talk about 'Europe on the road to world power' which has become so fashionable.[5] If we perceive Europe since the beginning of the permanent capitalist revolution as, in essence, developing from the dynamics of a self-fulfilling process of maximisation, it would have been more of a miracle if it had not been successful. A Europe which is not a world power is, for historical and systemic reasons, an impossibility; the principle of world power is the fundamental basis of the maximalism and experimentalism inherent in our system of civilisation—even though, for a few decades, the momentum of history seemed to have shifted away from its ancient focus and created new centres of interest in East and West.

If, as Weizsäcker correctly suggests, Europe does indeed reach from San Francisco to Vladivostock, then it does so not least because both the USA and the Soviet Union represent extensions of Europe itself; or, more precisely, laboratories in which certain aspects of European maximalism were rigorously tested and developed in competition with one another. Seen in this light, the so-called Cold War was nothing other than a competition between two concentrated experimental projects, both of which, in their deep structure, conformed to the same test conditions. This is why it was possible, in this case, to have a loser without having a decisive military confrontation—a novelty in the history of empires which would have been unthinkable under different circumstances. Behind the military arms race of the bi-polar era lay a more profound competition about the quality of life itself: a competition in terms of living, in producing and in enjoyment which, for the moment, has been decided in favour of the laughing liberal-capitalist West. Gorbachev's historic greatness lies in the fact that he, Lenin's most legitimate successor, proved to be precisely what he was, *de facto* and *de jure*: the leader of an experiment whose failure could no longer be concealed from the participants themselves nor from the rest of the world. His hesitant yet non-violent abandonment of the Soviet project can be regarded as proof that the Communist experiment was indeed conducted under conditions of falsifiability, and, as such, was a part, however problematic, of the project of the modern age. German and Austrian fascism, by contrast, bore all the hallmarks of a suicidal revolt against modernism. In its present state of collapse, the Soviet Union looks like a devastated laboratory which has seen an all too costly series of experiments in the neo-European concept of unlimited intensification

of power and life broken off without recourse to physical violence—but broken off with a view to adopting another, perhaps more successful, strategy of maximisation.

This conclusion would suggest that the assumption that Europe has, in any meaningful sense, abandoned its missionary aims is completely unfounded. In terms of its global ramifications, Europeanism is more virulent than ever. The fact that this continent, the mother of the modern age, has once again become the focus of historical events simply confirms that the European system of intensification continues to be a powerful force in its old heartland; it is as if the catastrophic reversal of 1914 to 1945 were mere interruptions rather than refutations of the basic experiment. The 'vacuum' of 1945 presented the ideal conditions, in many respects, for a radical reformulation of the experiment itself—especially in Germany, where the new beginning could proceed from an ideal state of nakedness. In conditions that resembled a politico-economic laboratory, the Germans embarked on an exercise in new-European maximisation which, in less than fifty years, made them world leaders in many areas—reason enough for their Western competitors to acknowledge the thoroughly modern character of the Germans. The very fact that Germany has been integrated into the North Atlantic complex is in itself proof that Europeanism is *the* system. The new European world is a learning, experimental mechanism, capable of optimising its potential, driven by self-intensification, and as such it is a system to which there is no alternative—or, rather, a system which absorbs every alternative into itself.[6]

Regions, Rights, Border Areas

I would like to add a third point to these observations on the global and systemic ramifications of the events of 1989—and this too goes far beyond the collapse of the wall and the de-Sovietisation of Eastern Europe and Asia.

One of the most pressing problems inherited by the successors to the Eastern empire, especially in the former Soviet republics of southern and central Asia, is the re-birth of Islam on a massive scale, frequently allied to rancorous forms of nationalism and tribalism. Western observers who view this phenomenon with concern see it as the manifestation of a concept which will, without doubt, remain a focus of elemental fear in the West for some considerable time: fundamentalism. Since the beginnings of Ayatollah Khomeini's Iranian revolution in 1978, proponents of the Euro-American way of life have been confronted with a representation of themselves in which they are depicted as members of an imperialist pornographic, inhuman civilisation dedicated to the destruction of moral values. The focus for this fundamentalist hatred (not just since the hostage crisis in the US embassy in Teheran) is the United States, in so far as it is perceived as the leader of Western nihilism. Europeans, too, have had good reason to become concerned that this kind of anti-Western caricature could be transplanted to the Islamic areas of the former Soviet Union, providing a platform for a hate campaign against the pilot nations of the permanent revolution. In the context of our third conclusion, we have to recognise that this so-called fundamentalism[7] cannot, by any means, be ascribed solely to misconceptions about the alien nature of the modern age on the part of its oriental enemies. In fact, conflicting conservative and sceptical attitudes towards modernism are

an integral part of the maximisation revolution in Europe itself; any attempt to dismiss fundamentalist resistance to modernism as an expression of the resentment of external competitors or victims is clearly contradicted by the facts. I would go so far as to assert that internal resistance to the permanent revolution of capital has been a decisive factor in shaping the political and cultural history of Europe in the nineteenth century, and even more so in the twentieth. This had its origin, to a large extent, in a partly latent, partly manifest, civil war between the agents of social upheaval and those against whom it was directed: in other words, between the mobilising and circulating sectors of the European world on the one hand, and the traditional order on the other. While industry, trade and banks practised their absolute right to revolution by overthrowing every aspect of the old European order—in villages and provinces no less than in the towns and cities— the voices of an internal Islam were raised on all sides in protest against the pornographic dissolution of everything in the world around them.

The Euro-Islam of the nineteenth and twentieth centuries had its stronghold in Catholic countries where, even today, there is greater resistance to unrestrained modernisation. Throughout the whole of the nineteenth century, there were, and still are, significant areas where tradition refuses to simply melt away. In this context, it makes sense to introduce the idea of a two-(or more) speed Europe—but to apply it retrospectively to the fact that the various areas of the Old World did not all participate in the same way in embarking on the age of absolute experiment. The dissolution of the world brought about by capitalist functionalism was not to everyone's taste, nor was it everyone's concern; only those who profited from modernisation were unreservedly in favour from

the outset of the break with traditional and local realities—the crucial point, incidentally, of the current German-French *Alliance à grande vitesse*. Those, on the other hand, who are on the periphery of the inner-European high-performance league are only too aware that there are twenty different ways of not being at the top—British resentment is an ironic expression of this awareness.

The vengefulness of the poorer performers can hardly be regarded as something new; it has been a factor of considerable historical significance in this century. After the First World War, as we know, the regions of the western Mediterranean specialised in a kind of holy alliance between provincialism and Catholicism—for which mafia-ridden southern Italy is paying a heavy price to this day. In terms of system theory, this observation is premised on the view that mafia practices represent criminal fast lanes towards economic modernism—lanes, it should be noted, through otherwise slow regions which legitimate enterprise finds unrewarding. The spread of the mafia in post-Soviet Russia is entirely in keeping with this picture. In Spain, Franco's semi-fascist regime (one could also describe it as integrationist, or Catholic-militaristic) only came to an end in 1976. From the very beginning, the new European dynamism was accompanied by polarisation between largely aggressive zones and largely disadvantaged zones which cut across the countries of Europe, and even divided individual nations. This polarisation formed the original context of the discussion about 'regions' in which the concept took on the specific emphasis it bears today.

A region is that which begins to think of itself as disadvantaged in the permanent revolution of capital; 'regions', in the narrower sense, are repositories of the old

way of life in the countryside and small towns, left in the wake of the revolution, which are continually forced to recognise anew that the rule of commerce has shifted to abstract urban centres. It is a tedious rude awakening for the inhabitants of the old countryside to discover that they have become the object of foreign calculations; they gradually begin to realise that their fate is being decided in the offices of distant banks and invisible administrations.

At the heart of this phenomenon of our older regions (or, if you like, our local Euro-fundamentalism) we find, for comprehensible reasons, an agrarian-Catholic syndrome, a complex and vital alliance of Roman anti-modernism and rural and middle-class anti-capitalism. The domestic casualties of the permanent new European revolution sought, by means of this alliance, to achieve what they regarded as their historic right: the expression of their self-assertiveness and the right to be regarded as emancipated participants in events, even under restructured power relationships.

The rural resistance movement, whether in the form of a Catholic corporate state or in the guise of fascist neo-paganism, has since become a historic anachronism; its source in the incensed rural population has dried up at the demographic level. All that remains is the fact that the dying-out of rural population has become a constant factor of the new European age. Two hundred years was all it took to sweep away the town and countryside culture which had formed the basis of an agricultural age. A cultural and social tragedy of enormous proportions is hidden in the most recent statistics which show that only two per cent of the population of present-day Germany are employed in the agricultural industry, compared to the more than four-fifths who worked at what was then

called farming at the end of the eighteenth century. Similar trends and comparable figures apply *mutatis muntandis* to all the developed nations of Europe—perpetuating a politically volatile gulf between the centre and the periphery.

The periphery comprises what have come to be known as structurally weak regions which lie furthest from the centre of the revolutionary cyclone and in which old European conditions continue to prevail. One could argue that, even today, there are very few who are inclined to acknowledge responsibility for the far-reaching consequences of the decline in agrarian activity in Europe. The bald sociological categories of 'urbanisation' and 'industrialisation' conceal the negative nature of the revolution which has hit the old agrarian communities and emptied the land.

The dying out of the farming community is really an evacuation of the countryside with the objective of freeing anything that could remotely be described as 'productive land' for use as a quasi-industrial resource and factory farming under the control of agrochemical and, sometimes, cooperative macro-economic units.

The region-consciousness which has appeared on the present-day agenda of the Western industrialised nations carries a quite different emphasis from the populist and integrationist reactions of previous decades. Wherever you look today, the regions are competing aggressively to become part of the great capitalist experiment, while the conservative, separatist, anti-modern and cantonal resistance takes a back seat. A new regional entrepreneurship has gained the upper hand; everywhere, community leaders, councils and planning officers are attending seminars by consultant experts and developers, devouring the gospel of city and regional marketing. Community

politicians are beginning to learn that underdevelopment on its own no longer constitutes a significant status today, regional thinking is defined in terms of entrepreneurial purpose. Areas with a large tourist industry have known this for a long time and the others are catching up bit by bit. One gets used to the idea that the countryside can be sold in the same way as waterbeds, cars and condoms and, as with those other commodities, the regions can exploit supply to encourage demand.

Under the ambiguous term 'region', however, there is, paradoxically, some overlap between conservative and progressive interests. What the one regards, even today—these days especially[8]—as home and hearth, the world of tradition, a quiet corner, the land of childhood dreams and the green biotope, the other sees as a market, a site, a resource, a commodity, a brand, an *appellation d'origine*; and both have sufficient justification for using the word 'region' in campaigning for their ideas. The word itself begs the question: who are the new rulers of these regions? To say *regio* is to refer, consciously or otherwise, to the ruling powers of an area, since the expression shares the same etymology as words such as *rex, rector,* rule and government. Conditions today dictate that this ruling power cannot continue to be lasting and permanent; it is not some ancient and holy alliance of clerics big landowners, farmers and local militia, but a slick team comprising representatives from the banks, industrial estates and the agrochemical industry, from property developers, shopping malls, garages and restaurants, with a few energetic community leaders, disco- and sex shop owners, thrown in. So we are no longer living in the good old days, in the land of Adalbert Stifter, nor in the land of Peter Rosegger, Heinrich Waggerl or Christine Lavant.[9]

Participants in the permanent revolution can be found meanwhile in every village. They have discovered the speculative potential of the small to medium-sized economic areas; they know that diversified capital has to trickle down to the regional markets if it is to yield a decent return in the future. And they know, too, that the ultra-fundamentalist money-mindedness of the people in the towns and countryside is more dependable than some kind of old European tradition of values.

The new region-marketing functions, in form and content, like an interior mission—almost, one is inclined to believe, like a crypto-Calvinist crusade led by the legionnaires of the permanent revolution against the last bastions of the agrarian-Catholic heartland with its stolid anger and inexplicable, joviality. The decline of the rural communities continues apace, transformed into the self-promotion of the regions. As we approach the end of the twentieth century, the fundamental principle of territorialism expressed in the Augsburg Pact of 1599 still applies: *cuius regio eius religio*—roughly speaking: you must adopt the beliefs of your masters. It looks as if now even the hitherto reluctant areas of Europe are ripe for a capitalist Reformation—and once Austria and Poland are members of the EC, it is difficult to see what would prevent the Vatican from becoming a member.

The new economic regionalism is, therefore, an attempt to eliminate the two-speed economy within each individual nation and to synchronise it with a homogeneous mean time. The inter-regional economy Europe is striving towards facilities the improved synchronisation of production—the clocks in upper-Austria, for example, should not be set to run differently from those in New York and Tokyo. *Alpenhorns* and *lederhosen* could, hypothetically anyway, appear on a company's books as

equivalents to aeroplane turbines and PCs. Thanks to regional marketing, commodities that seem to be worlds apart come into being simultaneously in ontological terms—the synchronisation of products through money cancels out the time difference in methods of production and way of life. Since this would appear to eliminate, temporarily at least, the dangers associated with differing speeds of progress within the system, Europeans have, for the moment, reasonable grounds to assume that they are not going to be confronted with an African situation on the peripheries of their continent.

From an evolutionary perspective, there are good grounds for contemplating the decline of the agrarian-Catholic complex with a degree of concern. In its wake, the status of the entire *Seins-Region* which, in the language of the old European ontology, used to be called 'nature', has changed. The moment the old land became an active factor in the new European experiment, nature ceased to be what it had been hitherto: the great mother and absolute fount of life; it has become a biochemical laboratory, it has been turned into an arena for open-air productions, a scenic route on which consumers commute between work and pleasure. In this context, the current Biosphere 2 Project in the USA is significant at least as a symptomatic experiment—the natural world with food and non-food in a fully-climatised hall. If one were to draw the obvious conclusion from such projects, the slick progressive regionalism of the new community enterprise could lead to more sinister consequences than the old rural defiance of modernity. Human beings have no experience of an existence conditioned by total experiment in which natural conditions, the soil, the landscape, the old communities are increasingly subordinated to the constructivism of permanent turmoil. One can see it coming:

some day, losers will be identified by the fact that they still talk about nature, whilst winners play with projects and constructs. The logical border between the old world and the new runs straight through the middle of the regions—perceived in old-world terms, on the one hand, as offering continuity and *Lebensraum* for people of character who require no other justification for their existence; conceived, on the other, as a widely-diversified business and multi-purpose site with a comprehensive communications network.

It is plausible, to my mind, to regard green, conservationist regionalism (which is often an urban concern) as an internalised and metaphorical response to the decline of rural life in Europe; it is as if sensitive city-dwellers today felt that they cannot remain completely indifferent to the disappearance of the rural guardians of the old land. The ecological and neo-religious holism of the townspeople represents a somewhat ironic continuation of Catholic essentialism by other means—what else is eco-conservatism but a metamorphosis of the *ordo-concept* in biological language?

But is it too late to think about the cosmos and the Grand Design? The paradigmatic status of the cosmos is being eroded by chaos. Conservative anxiety about post-agrarian, post-Christian society also reflects an awareness that the victors in the Cold War cannot presume that the collapse of the Eastern experiment will ensure the long-term success of the Western model. The principle of falsifiability continues to apply even to the still unrestricted liberal-capitalist experiment: one suspects, however, that the failure of the constructivist revolution would lead to a disaster of far greater proportions than the bankruptcy of the Soviet Union. In the experimental world, the old regions are a reminder of the indispensable need for a

policy of discretion in favour of survival. While the modern majority is inclined to stake everything on the success of the capitalist experiment (for reasons which are only too understandable), conservative, conservationist minorities should not be deflected from the task of keeping alive the memory of the old countryside and time-honoured ways of life. Perhaps these conservative forces will inherit an important progressive role sooner than anyone would like.

Notes

1 *Manifest der kommunistischen Partei, NEW 4*, Berlin 1977, p.465.
2 In his remarkable book *Gesamtkunstwerk Stalin; Die gespaltene Kultur der Sowietunion*, Hanser, 1988, Boris Groys has attempted to show the connection between Russian avant-garde art and Stalin's claim to having created a Communist synthesis of life and art. This is enlightening as long as one perceives the experimentalism of the modern age as a totality whose validity extends beyond the increasingly implausible dichotomy between art and life.
3 The lascivious tone of speculation on the part of German editors, in particular, can be clearly seen in the case of British historian Walter Laqueur's book *Europe in our Time* (New York, Viking Penguin, 1992). This thoroughly sober and sceptical work was published in Germany under the title *Europa auf dem Weg zur Weltnacht — 1945–1992* (Munich, Kindler, 1992). This is an illustration of venal hysteria in thesis-marketing aimed at displacing political theory.
4 After the siege of Vienna by the Turks in 1683, Europeans were not engaged in any other military conflict with any non-European power on their own territory until 1917.
5 See note 3.
6 Herbert Marcuse introduced a similar idea in the 1960s with his theory of the one-dimensional society. Today we can see more clearly why the revolutionary expectations of the Left in our century were destined to remain illusory. Since no one took Marx's perceptive observations on the permanent revo-

lution of the 'bourgeois age' sufficiently seriously, Marxist writers, too, underestimated the resilience inherent in the adaptable fundamentalism of capital.

7 The 'fundamentalism', which has its origins in the anti-modern Protestantism of North America of Gilles Kepel, *La revanche de Dieu, Chrétiens, Juifs et Musulmans à la reconquète du monde*, Paris, Editions du Seuil, 1991.

8 Hermann Lübbe has spent more than a decade developing an interpretation of this increasing identification with home and roots. He regards it, in terms of compensation theory, as a valid modern response to the accelerated withdrawal of familiar ways of life. Cf. i.e.: Hermann Lübbe, 'Die große und die kleine Welt, Regionalismus als europänische Bewegung' in *Die Identität Europas, Fragen, Positionen, Perspektiven*, Werner Weindenfield (ed.), Munich, Carl Henser Verlag, 1985, pp.191ff.

9 On the literary history of the tragedy of de-agriculturalisation, cf. the sensitive work of Ulrike Haß.

Translated from German by Michael Moohan.

4
Hors-champs

STAN DOUGLAS

'This is the music of the sixties and not a far-ahead thing.'
wrote a critic of the first album of a young tenor saxo-
phonist from Cleveland, Ohio, in 1964. 'It is Albert Ayler
and his men who are the exponents of today. If you don't
dig the music in this album, you should not blame Albert
Ayler, but maybe yourself as being behind the time.'

Nearly thirty years later, in 1992, at the Pompidou
Centre in Paris, Stan Douglas made a reconstruction of an
Albert Ayler session as it might have been filmed for
French television in the mid-1960s. Using just two cam-
eras rather than four or five, he recorded a live perfor-
mance of a jazz quartet in an anonymous sparse studio
setting in an 'abstract' style favoured by the cameramen
and producers of 'modern' musical television. The result-
ing piece comprised two video projections onto a large
double-sided suspended screen. One side presented a
'programme' cut of selected sequences and shots, while
the other showed a parallel compilation of all the footage
that had been edited out. The technique of filming, edit-
ing and presentation—a simultaneous dialogue between
two cameras—reflected the collaborative interchange in
improvisation which is at the heart of free jazz.

HORS-CHAMPS

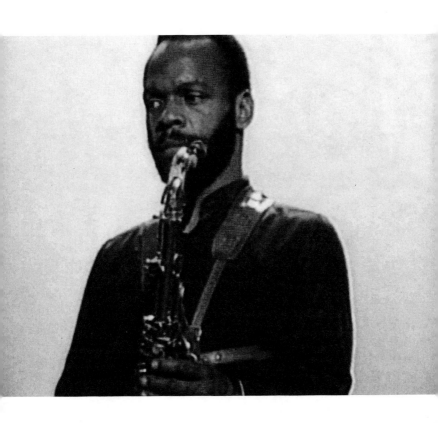

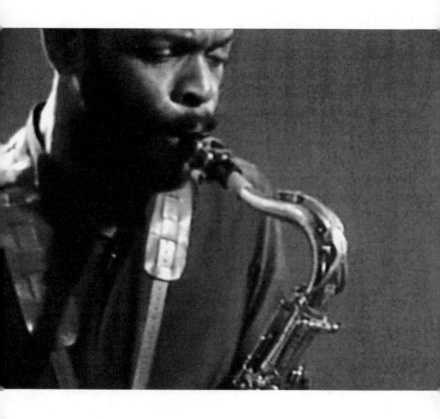

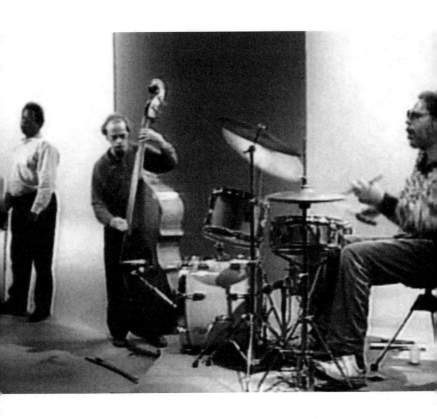

In Europe, where Afro-American music of the 1960s found a new cultural milieu, free jazz was a paradigm of a revolutionary attitude: not merely a development of ideas rooted in the tradition of blues and jazz, but a radical gesture of liberation from the norms of Western musical culture, from the subjection of expression by the almost canonical authority of tonality and harmony. ... In France it became one of the symbols of the revolt against the dominant dualism of the Cold-War culture and, Douglas points out in a press release, was particularly popular among *les soixante-huitards*, the generation of 1968. 'There were even festivals organised by the Communist Party, which regarded the music as an ideal of social organisation.'

Douglas examines the resistance of a deeply personal musical language to the regime of mass mediation, that is to say, the resistance of artistic 'freedom' to the techniques and technology of arbitration. Questions of identity, in cultural terms, seem to be paralleled here by those of 'authenticity'. The performance of a past composition (Ayer's *Spirits Rejoice*), itself based in part on pre-existent musical material, is transformed into an audio-visual spectacle fictionalised by the fact that both the music and its 'televised format' are reconstructions. The alternative counter-narrative which Douglas offers on the verso of the projection screen further confirms the fiction—for here too the artist's choices and decisions were dictated by the demands of style of an imaginary 1960s' editor—and serves as a reminder of the arbitrariness involved in the construction of any notion of 'identity' or, indeed, of political 'freedom'.

Note

The text is an edited extract from a review by Pavel Büchler of Stan Douglas's installation at Transmission Gallery, Glasgow, June 1993, *Creative Camera* 324, October 1993, pp.48–9.

5
Modernism and the Nazis
A Nightmare

NEAL ASCHERSON

What would have happened if the Nazis had embraced modern art? The very thought seems idiotic. We are brought up to accept that dictatorship has its own taste: muscle-bound literalism. So how could National Socialism have declared the German Expressionists and their successors—marvellous painters like Beckman and Kirchner, Kokoschka and Nolde—as cultural heroes of the Nazi 'national uprising'? And yet they might have done so. And if they had, we would be looking at art now in a quite different way.

The dogma that the Nazis were always fiercely anti-modern survives. So does the related assumption that the avant-garde painters in the Germany of the 1930s were politically left wing. Neither is true. Otto Dix, for example, is best known for his shattering images of trench war, mostly done in the 1920s. Work like that produced since 1945 is instantly identified as the expression of left-wing pacifism, and indeed the socialist wing of the anti-Nazi emigration from Germany had already claimed Dix as an ally after 1933. But the 1920s were different times, and Otto Dix was not a communist—in fact, he was quite unpolitical.

The painting generation to which Dix belonged is labelled *'Neue Sachlichkeit'*—'New Objectivity'. Some of his contemporaries, like his friend George Grosz, were communists or socialists of other varieties. Many, however, were not, and their sense of a world ending, of an order foundering in blood and chaos, was not unlike the perception that took conservative revolutionaries into the Nazi movement.

These brief opening observations can serve as an introduction to the minefields of perception which surround this topic. Surfaces are treacherous here. But now I want to enter one of these minefields and, carefully, to look at its booby-traps.

What was the most successful exhibition of modern art in this century? I mean successful in the senses of both attracting the public and of changing substantially the course of artistic development in the ensuing years. The answer, I am sorry to say, is highly disagreeable. It was the exhibition of 'Degenerate Art' (*Entartete Kunst*) opened by Adolf Hitler in Munich on 19 July 1937.

The exhibition, which held the entire Modern movement in German painting, graphics, sculpture and architecture up to ridicule, contained no fewer than 7630 works of art. Not all of them survived into our own times. But among them were works considered now—and indeed before Hitler's accession to power in 1933—as marvellous and immortal expressions of human genius. The list of the involuntary 'exhibitors' is too long to reproduce but among them were Paul Klee, Otto Dix, Ernst Barlach, Max Beckmann, Emil Nolde, Oskar Schlemmer, Lionel Feininger, Kaethe Kollwitz, Georg Grosz, Emil Kirchner and Willi Baumeister.

Entartete Kunst was an instant and enduring winner. No fewer than two million people visited it between July and

November. Most were German but many foreigners made the journey to Munich specially. Hitler himself went round it, accompanied by Goebbels and the bigwigs of the Reich Arts Chamber, the Nazi guild of artists. After Munich, the exhibition went on tour, opening in Berlin, Hamburg, Leipzig and other cities.

There is a comforting fib put about, which is that the enormous rush of visitors who wanted to see 'Degenerate Art' was composed of secret fans: admirers of Expressionism, Post-Expressionism or the Bauhaus who went only to see for the last time the works of modern art they loved and understood so deeply. But this is rubbish. There were certainly some among the crowds who felt like that. There is even one recorded case of a collector— Bernhard Sprengel—who was actually converted to Modernism by what he saw in that show. The vast majority, however, went for the reasons the Nazis hoped for. They thought modern art was mad and sick, and they regarded the exhibition as a sort of magnified circus freak-show. As one depressed spectator wrote at the time: 'The aim of the propaganda, which was to deal a death blow to genuine modern art, was in large measure achieved.'

The exhibition was remarkably well presented. In our own times, especially in Thatcherite and post-Thatcherite Britain, art galleries have to wrestle with unfamiliar concepts like sponsorship, marketing and targeting. 'Degenerate Art' would have had no problems there. The sponsors of *Entartete Kunst* were not directly the state, or the taxpayer, but the Party--the National Socialist German Workers' Party. In each city, when the exhibition went on tour, the local Nazi regional organisation took on sponsorship, giving the show a spurious flavour of spontaneity. Marketing and targeting were adept. Nobody had

to be threatened with a holiday in Dachau if he or she didn't go. Instead, there was mass advance ticket selling at reduced prices, with huge publicity. In addition, the show was 'sold' as an adjunct to a spectacular official event close by: the opening by Hitler of the new *Haus der Deutschen Kunst* with the Nazis' own 'Great-German Art Exhibition' inside, which took place on the following day to the 'Degenerate' opening.

Targeting was simple enough. The exhibition was not aimed at the converted Nazi ideologues. It was aimed at the million upon million of stupid, racialist, half-educated people who thought the problems in their lives were caused by Jewish department stores, negro jazz bands, Russian atheists and posturing perverts. It scored a memorable bull's eye. Adolf Hitler now spoke for everyone who had been boiling with suppressed rage against Modernism, for everyone who had been made to feel a clown for pointing out that people are not made of cubes and triangles:

> There really are men who see today's Germans as simply degenerate cretins, and who perceive—or as they would no doubt say, 'experience'—the meadows as blue, the sky as green, the clouds as sulphur-yellow, and so on. I do not want to enter into an argument as to whether or not these people actually do see and perceive things in this way, but in the name of the German people I wish to prohibit such unfortunates, who clearly suffer from defective vision, from trying to foist the products of their faulty observation on to their fellow men as though they were realities, or indeed from dishing them up as 'art'.[1]

The presentation of the show was also—as the modern cliché has it—'exemplary'. The cultural historian Hermann Glaser has pointed out the deliberate contrast

between the new 'pure' art housed in the supposedly beautiful new Haus der Deutschen Kunst, and the 'ugly' art squeezed into the obsolete old gallery on the Koenigsplatz. Squeezed is the word. The paintings and sculptures were crowded together on the walls, and some even stood on the floor as if just unpacked. This was deliberate. It was calculated to convey a sense of chaos, of claustrophobia, of unhealthiness, and to make the visitor feel like throwing open a window. Large didactic texts, explaining in Nazi terms the sickness of the exhibits, sprawled across the few empty spaces. And beside each picture, neat and nasty, was a ticket stating the last price it commanded. Trendy profiteers, it was implied, paid a worker's annual salary for this garbage.

The exhibition was divided into sections: 'Mockery of German Womanhood', 'Vilification of German War Heroes' and so on. Professor Adolf Ziegler, president of the Reich Arts Chamber, told parties of tourists, 'Around us, you see the monstrous products of lunacy, impudence, dilettantism and degeneracy.'

His own heavy, literal female nudes were in the other, 'good' exhibition. Not for nothing was Ziegler known as 'German master of the *mons veneris*'. All the same, the monstrous products were not considered too horrible to sell. When the show was finally over, in 1939, many of its works were sold by the German government in Switzerland, leading to one of the greatest dealer-stampedes in art history. However, an enormous mass of paintings and drawings was left over. The authorities let it be known that they were burned as part of a training exercise by the Berlin Fire Brigade. This was a lie, but it was what they wanted the world to believe.

Hitler was flattering public opinion. Ordinary people knew what they didn't like, he implied, and they were

right. 'The artist does not work for the artist, but like everyone else he works for the people. And from now on we shall see to it that it is the people who are called upon to judge his art.'[2] Stalinism, too, proposed heroic realism as the 'correct' style and claimed that this was what the people liked. But in the Soviet Union and after 1945 in eastern Europe, the people (or the toiling masses of the proletariat) were never given a chance to show what they really thought.

Nazi Germany was different. Hitler often dealt in authentic public opinion, channelled to his purposes but based on genuine feelings. That is why the impact of *Entartete Kunst* was so terrible and long-lasting. It revealed the extent to which Modernism was resented and even feared by ordinary people, more than half a century ago. And it also revealed, in the pages of Western cultural magazines and reviews, how many intellectuals and critics still loathed the Modern movement and its consequences.

The *Entartete Kunst* catalogue juxtaposed the paintings with work by mental patients; other exhibition material put together Expressionist representations of the human body with photographs of gross deformity in hospital patients. The association of artistic distortion with the symptoms of disease (an utterly senseless comparison) gained strength. That, too, was to be adopted by the Stalinists, who insisted that the literal was also the progressive and healthy, while abstraction or non-realistic art was the surface rash of bourgeois decadence.

But one thing has to be said: it is pure hindsight, and nothing better, to claim that totalitarian political systems naturally select a literal and figurative style as appropriate to their new millennium. The prelude to the *Entartete Kunst* shows this well. For Hitler's decision to go down

this road came after long hesitation, and after prolonged and bitter rows within the Nazi movement. It is fair to say that the failed Viennese art student was conservative in his own taste, and always associated Expressionism with disloyal and anti-national views, especially with Bolshevism. But the revolutionary element in German and Italian fascism, the Strasser tendency in the Nazi movement before the purge of 1934, took a different view.

It is a pretty incredible thought that Expressionism itself might have become the official Nazi art-style. It is true of course that not all the practitioners, from *Die Bruecke* through to the *Bauhaus* were women and men of the Left. Take Emil Nolde. Nolde actually joined the Nazi Party in 1920, more or less at the first hour. When he fell into disfavour, he could not believe what was happening to him. But this was not the point. What we easily forget is how deeply and passionately the German intellectuals had responded to early Expressionism even before the outbreak of the First World War. By 1914, Expressionism was on its way to becoming semi-established or, as one modern critic has put it, 'accepted as the natural language of the German spirit'.

In 1933, when Hitler became Chancellor, it was therefore natural that many dealers and gallery directors and curators thought that it might make sense to go for Expressionism as the German national style. Goering was only one of several Nazi leaders who bought these works—he liked Nolde. And the intellectuals and sympathisers were reassured by what had happened in Italy, where Futurism had been promoted to be the art of the national revival. This line of thought was represented by the mixed group of people who seemed to revolve round the journal *Kunst der Nation*, especially Andreas Schreiber

who wrote in 1933 that 'the promoters of the national revolution in Germany were the artists of *Die Bruecke*'.

A critic agreed with Schreiber:

> It cannot be denied that it was the New Art itself which prepared the way for the national revolution. ... The promoters of the national revolution in Germany were the artists of *Die Bruecke* such as Nolde, Otto Mueller, Heckel, Schmidt-Rottluff and Pechstein, the artists of *Der Blaue Reiter* such as Franz Marc, Macke, Klee and Feininger, the sculptors Kolbe and Barlach and the architects Pölzig, Tessenow and Mies van der Rohe, to name but a few.[3]

On the other wing were the Nazi ideologues, the biological warriors. In 1927, Alfred Rosenberg himself had been one of the founders of the Kampfbund für Deutschen Kultur (Battle-Group for German Culture). With him was the horrible Paul Schultze-Naumburg, who was later to have the pleasure of personally painting over Schlemmer's Bauhaus murals in Weimar. The Kampfbund went straight for the association of non-realistic art with physical and mental disease, and it was the Kampfbund which started showing Expressionist representations of the human body alongside photographed deformities. Anyway, the battle between *Kunst der Nation* and the Kampfbund over what was to be the official style broke out in earnest when Nolde applied to join the Kampfbund and—to his own bewilderment—was refused.

The battle was still raging when in 1934 the Italians sent a major Futurist exhibition to Berlin. This show drew a curious response from Adolf Hitler himself. He called down a plague on both houses. He attacked the anti-traditional corrupters of art whom he called 'alien both

racially and nationally'. But he also savaged what he described as 'backward-looking cranks who think they can spin an old-style German art out of the muddled world of their own imaginings'.

What was going on here? Nobody really knows. To some extent, Hitler was practising one of his favourite spectator sports: letting rival factions within the Nazi movement fight it out to the death—the Darwinian life-struggle for the survival of the fittest transferred to institutions. Anyway, by 1936 the Führer had tired of the struggle, perhaps following the final suppression of the Strasser faction and other so-called revolutionary elements in the movement. Hitler came off the fence and, in cooperation with Goebbels, commissioned Adolf Ziegler—he of the *montes veneris*—to start collecting for a show of degenerate art whose centre-piece would be Expressionism and Post-Expressionism. At the same time, the decision was taken for the heroic, ultra-naturalist style. So began the triumph of sculptors like Arno Breker (who was a respectable artist while he stayed within the influence of Maillol), and of painters like Hubert Lanziger who did that famous picture of Hitler as Joan of Arc, on horseback. Hermann Glaser sums it up:

> Everything was either heroic or idyllic, sweet or racial-ist; it was all beautiful and put like the allegorical fig-ure of the Third Reich, by Richard Klein, which stands naked and bare on a desolate rock holding a hammer veiled by a halo and a banner bearing the swastika and the imperial eagle, muscular and pea-brained, vacant-ly staring into a 'better future'.[4]

The lasting damage of all this poison was twofold. Both types of cultural damage only became evident after 1945, when Hitler had been overthrown and when artists were

in full flight from every standard laid down by totalitarian systems. The first was to discredit all thoughts that artistic values and public opinion might have a useful connection. That way, it was assumed, lay barbarism.

People forgot how, in the previous century, it had seemed natural to poets and musicians and painters to 'take their art to the people' in order to inspire them. There is a famous poem by Cyprian Norwid about how the Cossacks who stormed Warsaw in 1831 threw Chopin's piano out of the window, so that 'art hit the pavement': a parable about the way that high art can give purpose to masses of anonymous people in the hour of crisis. And in the war which had just ended, both British and German workers had crowded to listen with passionate attention to symphony orchestras playing in munitions factories or shipyard halls. In the last months of 1989, a playwright led a revolution from the basement of a theatre and became president of Czechoslovakia, while a poet ran to the television studios in Bucharest, joined the revolutionary committee and told the nation in verse that the sun of liberty had risen.

The second kind of damage was to the relationship between visual artists and the world they perceived around them. The best way to understand this is to take a case—Willi Baumeister, for instance.

Baumeister and his friend Oskar Schlemmer were teachers of art at Frankfurt. Both lost their jobs as early as 1933 and both had work hung up in the pillory of the *Entartete Kunst*. But, unlike many of their friends in the Modern movement, they did not leave Germany. Instead, they were amongst those who went into 'inner emigration', their work banned and confiscated, even their whereabouts known to very few. They were helped by a paint manufacturer in Wuppertal, who gave them jobs in

his varnish research laboratory, and both men continued in private to create their own works of art.

This was the Inner Emigration. This was the beginning, after Art for the People, of Art for No-One. Baumeister, in unpersonhood during the Third Reich and during the first post-war years, turned to abstraction. In his article entitled 'Das Unbekannte in der Kunst', which he had started in Wuppertal but which he published after the war in 1947, Baumeister writes about this turning inward:

> Art has progressed along the path from dependence to independence, from the commission which is given to personal responsibility. The free autonomous artist received his commission from himself.[5]

So it came about that, after the war, a new line was drawn-between abstraction as the 'Art of Liberty' and representational art perceived in the West as 'accident-prone'—easy to subvert in the cause of totalitarian propaganda. This swelled into an absurd dogma, in America but above all in West Germany in the 1950s and 1960s, where representative art came to be grounds for suspecting communist sympathies in the artist. It seemed to escape notice that the 'Neue Sachlichkeit' people had been both figurative artists and victims of Nazi persecution, and that their realism had nothing to do with the heroised 'pass-me-a-brick' works of Socialist Realism under Stalin.

The German critic Peter Klaus Schuster put it:

> Abstract art seemed to those who practised it an autonomous creation and something far more valuable precisely because it was a product of the intellect. An art which apparently transcended the events of every-day life, which set its sights on archaic and fundamen-

tal forces, on formative powers of the earth, on disem-
bodiment and on spiritual overtones seemed to be
born out of the ashes of Nazi Germany as a new art.[6]

This precedence of the spiritual extends as the constant
factor in modern German art from Kandinsky right down
to Baselitz, with his insistence on seeing things in relative
terms and his denial of the objects in his paintings.

This yearning for a higher purity and truth in art
beyond all triviality, all ugliness and all the political
scandals of life is certainly a feature of modern
German art which was decisively fostered by the
exceptional circumstances of the 'Inner Emigration'.
Similarly, the concept of the almost religious function
of art as a means of lending a spiritual quality to life
and, indeed, of transcending life itself, and the notion
of the artist as a chosen member of society, pursuing
his lofty *métier* away from the hurly burly of everyday
life were the real rocks on which the 'Inner Emigration'
was founded.
 Their art was for no one; their art served art alone—
all this makes clear that the art of the 'Inner
Emigration' was part and parcel of a very typically
German vision of art and the artist. From 1800, from
the days of Hölderlin, Runge and Caspar David
Friedrich, the artist in Germany has felt himself a priv-
ileged expatriate, who sees himself as a stranger in his
own land.[7]

To this vision Nietzsche added the dimension of the noble
elitism of the heroic individual. German introspection
and the 'Inner Emigration' would appear therefore to be
two aspects of the same flight from life into higher, deep-
er areas of spiritual values.

Let us now play the 'If' game. Suppose Hitler had
chosen the other way, and Modernism up to and includ-

ing Klee had become the official art of the Thousand-Year Reich!

The first and most obvious result is that the emigration of painters and sculptors would have been much smaller. (Compared to the flight of literary and scientific intellectuals, it was never very large: Otto Dix, Emil Nolde, Willi Baumeister and Oskar Schlemmer were among those who went to ground in Germany and survived. Perhaps this was because artists have long roots. But it may also have been to do with the surprisingly small number of contemporary German painters from Jewish origins.) And the West, above all the United States, would not have received the painter-teachers who, a few years later, were to generate the eruption of abstract expressionism.

The second consequence might well have been to leave abstract painting as an interesting but marginal affair on the fringes of art. The identification with political liberty and economic individualism—quite accidental, really—would almost certainly not have taken place.

The third and by far the most important consequence would have been to undermine the entire Modernist movement in the 'democratic' world. 'Modern Art' would have been associated with fascism in both its Italian and German forms. In spite of the existence of a German avant-garde which was too strong for the Nazis to take, intellectuals in France, Britain and the US would have been powerfully tempted by the notion that art which 'distorted' liberal perception was dangerous and in some way anti-human, while 'soundness' must lie in dogged realism. Some people on the left would have gone on to point to Soviet art, with its 'heroic naturalism', as the true heir to the European tradition. Others would have objected to the communist propaganda which was inherent in Socialist Realism, but even they would never have made

today's facile identification of Soviet with Nazi art as artistically and morally equivalent. There would have been only one 'totalitarian style': Modernism.

It is easy to see what would have followed, especially as war approached and the West began to prepare its own propaganda attitudes for its own civilian populations. We need look no further than Munich 1937.

The point here is simple and nasty. If the Nazis had adopted Modernism, something like the 'Degenerate Art Show' would have happened here instead. It would have taken the form of some grand mockery of 'German Art', put in national rather than cultural terms to suit wartime propaganda needs. It would have mobilised the hatred and incomprehension of Modernism which was stewing away in Britain and the United States as well as in Germany, and built it irrevocably into the programme of democracy. Even back in 1937, some Western critics who were by no means pro-Nazi were impressed by the 'Degenerate Art Show'; Raymond Mortimer wrote in the *New Statesman* that Hitler had achieved at least something worthwhile: 'the best thing we have heard from this gentleman so far.' All that was most philistine and reactionary in British taste would have been co-opted into the war effort. After Hitler's defeat, vengeance would have been taken not just on the Nazis as a movement but on all the 'monstrous products' of their 'degenerate' imagination.

History as it really did happen took a heavy toll of the work of the 'Neue Sachlichkeit' generation. Several of the very greatest of Otto Dix's works were lost in the Nazi period (though it is just possible that, in these years of rediscovery, a Dix masterpiece may yet turn up lining some shed room in Brandenburg). But if the young British and American soldiers in Germany in 1945 had been taught that Modernism was the art of evil, than almost

everything would have gone to the torch. The Nazi decision to declare war on the Modern movement was a disaster. But a decision to sanctify it would have been, in the end, far worse.

Notes

1 Quoted in *Entartete Kunst*, exhibition guide, Munich 1937.
2 Quoted from Günther Busch, *Entartete Kunst: Geschichte und Moral*, Frankfurt, 1969, p.22.
3 Bruno Werner, *Deutsche Allgemeine Zeitung*, Berlin, 12 May 1933.
4 Hermann Glaser, *The Cultural Roots of National Socialism*, London, Croom Helm, 1978, p.56.
5 Willi Baumeister, *Das Unbekannte in der Kunst*, Cologne, 1960, p.106.
6 Peter-Klaus Schuster, 'The Inner Emigration' in *German Art in the 20th Century: Painting and Sculpture 1905–1985*, London, Royal Academy of Arts and Prestel Verlag, 1985, p.462.
7 Ibid.

6

Casablanca

Where Have All the Fascists Gone?

COLIN McARTHUR

When *Casablanca* was released, round about Christmas 1942, no one was in any doubt about its meaning. Warner Brothers, in a magazine advertisement late in 1942, explicitly linked the film to the allied landings in North Africa on 11 November of that year and spoke of *Casablanca* as a 'symbol of the American way of living', that is, committed to democracy. A film trade magazine of the time wrote that:

> *Casablanca* ... opened Thanksgiving night under the sponsorship of France Forever and the Free French War Relief. Prior to the performance ... a Fighting French Delegation of Foreign Legionnaires, veterans of North African warfare, aviators recently returned from the battle fronts and leaders of the De Gaulle movement paraded from the Free French Headquarters on Fifth Avenue to the theater. Recruiting, souvenir and other booths were set up by the delegation...[1]

In 1942/3 it was impossible to view *Casablanca* as other than inseparably locked into the Second World War and its central meaning as other than the moral choice of the individual to be passive in the face of, or actively resist,

fascism. In certain respects, the composite figure of Rick/Bogart became *the* emblematic anti-Fascist hero of the time, initially reluctant to make a commitment but driven by human decency into an active stance against fascism.[2]

In 1992, *Casablanca* was re-released. To mark its half centenary, a special commemorative poster was issued with the figure of Rick/Bogart at the centre of the composition as the forward point of a triangle which unites him with Ilse/Ingrid Bergman and Sam/Dooley Wilson, the black singer/piano player. The meaning is clear—*Casablanca* is a film about a love affair between Rick and Ilse, with Sam tying them together through the playing of 'As Time Goes By'. In the right lower foreground of the poster is a German military cap, the sole concession to the film's connection with the Second World War, and the key anti-fascist figure, Victor Laszlo, is nowhere to be seen. Over a period of fifty years politics has been evacuated from the film.

How did this come about?

It is not that the film passed from memory over this period; but rather that the massive presence of quotations from, and references to, *Casablanca* in cinema and in popular culture as a whole operated within strict parameters of meaning, oscillating around the ideas of cult, romance and nostalgia.

This began quite soon after the release of *Casablanca*, with the appearance of *A Night in Casablanca*, the Marx Brothers' movie, which recognisably grows out of the earlier film and, in certain minor respects, explicitly refers to it. In particular, it retains the anti-fascist theme. *Casablanca* then seems to have vanished from cinematic consciousness for about a decade and to have resurfaced on the back of an emerging cult centred on Humphrey Bogart as

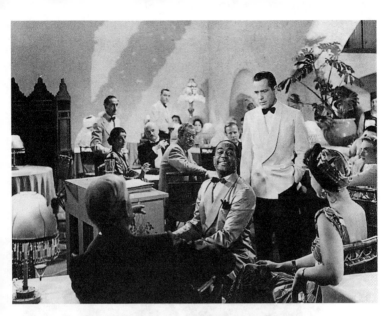

Casablanca, dir. Michael Curtiz, 1942. Repressed dimensions:
the large cast (above) and the Nazi/Vichy regimes (below)

A Night in Casablanca, Marx Brothers, 1946

Diane Keaton and Woody Allen reprise the Bergman and
Bogart roles (above), while the ghost of Bogart (below) helps
Allen's love life in *Play it Again Sam*, Woody Allen, 1972

Leslie Nielsen says 'Play it again Sam' in *Naked Gun 2½: The Smell of Fear*, dir. David Zucker, 1991

Robbie Coltrane as 'The Bodie Man', BBC 1990

Casablanca reprised in a 1980s 'Limit Watch' TV commercial

Kermit and Miss Piggy as Bogart/Bergman in *The Muppet's Christmas Special*

an existential hero shorn of political affiliations. This is most evident, for example, in Jean-Luc Godard's first film *A bout de souffle*, in which the small-time crook played by Jean Paul Belmondo explicitly identifies with Bogart.[3]

The screenwriter Howard Koch, wrote in 1968 about his involvement with the film:

> In recent years a sort of mystique has grown up among the younger generation around Casablanca, which probably has played more revival dates than any other film and is now being prepared for the musical stage. Students tell me of 'Casablanca Clubs' in many colleges in which members are expected to attend a showing each time it is revived in their area. Some have reported seeing it as many as fifteen times...[4]

Out of this, there emerged the film most obviously intertextual with *Casablanca, Play it Again, Sam*, written by and starring Woody Allen, with Allen, Diane Keaton and Tony Roberts in the Bogart, Bergman and Henreid roles. Concerned solely with romance and the sexual problems of the protagonists, Allen's 'homage' to *Casablanca* begins to evoke the other mode so central to the modern world—nostalgia. A piece in *Sight and Sound* in 1968 begins:

> No two ways about it, we say with comfortably complacent pessimism as we get up from an evening's television: they don't make pictures like that any more. What we mean can be summed up in one word: *Casablanca*...[5]

However, it is a nostalgia which is prepared to repress politics.

From the mid-1970s the cultist and nostalgic references to *Casablanca* become delirious and omnipresent: '*Casablanca*, the aftershave that lingers on'; the comedy rou-

tines of Morecombe and Wise, Bobby Davro and Russ Abbott; a Eurovision Song Contest entry; the name and campaigns of an Austrian brand of cigarettes; the advertising of Moroccan oranges; high-grade British papers and a German airline; and even a Ninja Turtle card. The title and lyrics of 'As Time Goes By' serve as the titles for books not remotely connected with the song, and function as sub-editors' headings in newspapers and magazines. The 'real' *Casablanca* in Morocco begins to be reconstructed to fit the tourist's image of the fictional *Casablanca* of the film, and the Hyatt Regency Hotel in *Casablanca* opens Rick's Bar based on the decor of the bar in the film.

So hegemonic have the modes of cult and nostalgia become in discussions of Casablanca that, alongside the repression of the 'historical' dimension of anti-fascism, entry has been forbidden to recent political discourses. Whilst the film's cult status and its intertextual ramifications became the subject of papers by Umberto Eco and Thomas Sebeok, one might search the literature in vain for an analysis of *Casablanca*'s politics. It is surprising that there have been no feminist readings of the film, given the extent to which Ilse would seem, *prima facie*, to be a pawn between Rick and Laszlo; it is curious that the substantial work on the representation of blacks in the cinema, over the last decade, has not included an examination of the role of Sam in *Casablanca*, particularly since some of the dialogue is overtly racist; and, given the impact of Edward Said's work in recent years, it is striking that no analysis of the West's encounter with the orient has been brought to bear on *Casablanca*.

Re-readings of art works of the past are inevitable. As some of the more 'Frankensteinian' aspects of nationalism reassert themselves in Europe and in the rest of the world,

we should perhaps remember that *Casablanca* meant something other than cult, romance and nostalgia to earlier generations. If today's audiences are wont to think of 'As Time Goes By' as the theme song of *Casablanca*, we can perhaps call to mind another of the film's several songs. Victor Laszlo, hearing the Nazi Major Strasser and his comrades singing 'Wacht am Rhein', strides over to the orchestra and orders it to play 'La Marseillaise' which, drowning out the Nazis' singing, incites from the clientele of Rick's Bar the cry 'Vive la France! Vive la démocratie!'.

Notes

1 *Motion Picture Herald*, 28 November 1942, p.58.
2 It is often forgotten that Bogart played an anti-fascist hero in several wartime movies such as *Action in the North Atlantic*, *Sahara*, *Passage to Marseilles* and *Across the Pacific*, and, indeed, reprised his 'reluctant anti-fascist' role in *To Have and Have Not*.
3 Bosley Crowther, writing about the Bogart cult in *Playboy* in 1966, dates the emergence of the cult to 1956, the year before Bogart's death, when the Brattle Theater in Cambridge, Massachussetts' ran *Beat The Devil* and got an unusually enthusiastic response from its mainly Harvard undergraduate audience.
4 H. Koch, 'Notes on the Production of *Casablanca*' in *Persistence of Vision*, edited by J. McBride, Madison, Wisconsin Film Society Press, 1968.
5 *Sight & Sound*, Autumn 1968, pp.210-11.

7

Walter Benjamin and 'Qualitatively Distinguishable Times'

IAN HUNT

> Does nature observe the Sabbath?
> (Samuel Beckett, *Molloy*)

On the London underground system, clocks with hour hands, minute hands and dials are being replaced by clocks with just numbers. The work proceeds slowly, and I suspect that for some time to come the stopped dials of the old regimen of time will coexist with the not yet functioning digits of the new.

As someone unable to wear a wristwatch with regularity, I rely on clocks in public places, and find a need to account for my resistance to the new clocks on grounds other than habit or nostalgia. It occurs to me that the split-second of delay needed to assimilate the time in two parts, as a relationship of the information of the hour hand and the minute hand, is distinct from the experience of time as number alone, moving inexorably onwards, to be merely read off. While the twenty-four hour clock remains undecimalised, it appears to complete an identification of the measurement of time with quantity, and implicitly, with the ideal quantity, money.

Time, particularly for dwellers in large cities of

advanced industrialised states, is now managed and internalised down to the finest degree, as Norbert Elias has shown brilliantly in *Time: An Essay*.[1] Nevertheless, the discretion offered by clocks without second hands about the minutiae of timekeeping keeps at bay the identification of time and quantity, of time and money, and the incessant checking and monitoring that go with these identifications; if only by a whisker. The face and circular movement of clocks with dials also preserve a connection with the etymology of the day—dial—and with the axial rotation of the earth; antiquarian notes perhaps, at this stage, but the degree of abstraction in digital clock time strikes me as a qualitatively different entity than that of the circular clock face. The exacting god of time now tries to hide his face in shame. In that some kind of progress seems to be implied by digital clocks, we have a right to ask exactly what kind it is.

Earlier generations found clocks with dials equally difficult to assimilate and internalise, probably far more so than the short, final step to digital time is for us. The eighteenth-century scientist and aphorist Lichtenberg wrote of 'God, who winds our sundials'.[2] The current invention of a misnomer such as *quality time*, which declares itself lame by the evidence it carries of a regulated attentiveness and care, suggests that, on the contrary, quantity is the dominant factor in our experience of time. Or not, perhaps, quantity itself, but the evidence that a store or allocation is being subdivided internally and distributed, according to an internally-administered audit, that may or may not serve or supplant efficiency.

This idea of time as a store, to be used with caution, and sensed overwhelmingly as moving in one direction, is far from universal in developed countries. The experience of travel makes it overwhelmingly clear that other attitudes

and habituations to time are widely practised. I have just returned to Britain after a journey by train from Beijing to Moscow, a journey I have long dreamt of making, passing through time-zones, and varying climates and on differing rail gauges, and through regions of very unequal economic and political development, including nomadic regions.

In Mongolia the two-tier economy comes complete with dimes and cents. As the train moved at a stately pace through Siberia and Russia, the stacks of roubles carried by Chinese traders seemed to acquire newly-printed, higher denominations, now bearing the Russian flag, though the fine engravings of the old low-denomination notes bearing Lenin's head still pass from hand to hand. The monthly convergence of official and unofficial exchange rates approaches: a much discussed matter, and apparently of greater significance than the temporal adjustments all the travellers have to make as the train threatens to arrive a calendar day later than expected.

Money is vitally at the centre of all interests, but time is left remarkably unmanaged. Once on board, abstractions such as Moscow time or Beijing time are so much irrelevant imperialism. The lateness only shows on the sometimes strained faces of those who come out to greet the train, to buy from it and sell to it. For the travellers, there is endless waiting and staring from the windows and games of cards. There appears to be almost too much time here. Some of the traders spend it exchanging stories or cooking magnificent meals, and some, in a brutal holiday spirit, on two Russian prostitutes who work the train for a day from compartment to compartment.

While the dollar is the triumphant *lingua franca* of the train, and is more substantial than the freshly curled leather jackets offloaded through the windows, its mean-

ings vary from place to place, and from person to person. Very few of these green tokens will ever challenge the treasury referred to on them. The stacks of notes get higher and higher, to be exchanged for favoured brands of cigarettes in Moscow for resale back in China. The seller of Soviet trinkets and fur hats has a home to return to, but he carries his entire wealth in dollars with him: a medieval figure, one would say, but he is part of the variegated temporal present of modernity, which carries in it many varieties and stages of development, and routinely reinvents the ancient.

I could go on describing the temporal and monetary confusions and shifts experienced on such a voyage, where almost everyone is habituated to trade in its most basic form, the trick of distance; but where, for all the profanity, one can escape quite completely from an excessively managed sense of time if one wants. Such a voyage is like an intercalary day, a restoration of vital rhythms. In the exotic capsule of such a train journey, my experience was of time as extravagant waste: surrounded by work that obeyed no rhythms of work I was familiar with, that appeared rather to be a form of disputatious competition, gaming and negotiation between less or better skilled bargainers. This different sense of time is, for the traveller, a precondition for certain kinds of thought and structures of remembrance inaccessible by other means, which are made difficult when hours and minutes are marshalled into an almost entirely pre-allocated framework of day. And for the traders the boredom is of a kind quite unlike that experienced in other work, in that it partakes of holiday: an unbridled kind of boredom, that produces fights, narratives, and outrageous bets and boasts.

A talk on 'qualitatively distinguishable times' is not a very obvious approach to the work of Walter Benjamin,

and so some exemplification of the varieties of ways in which we experience time—and an introduction to the terms—seems appropriate. I want to consider ways of understanding an experience of time as largely non-quantitative—by which I do not mean 'qualitative'. The habit of opposing these terms is sometimes misleading. The idea that all that is non-quantitative must therefore be qualitative is a fetishism of quality inversely dependent on our excessive valuation of quantity.

Benjamin's references to time are embedded throughout his texts on many other subjects. While his writings are vitally present to us, the subject of his particular attention, experience, was historically constituted and his reflections on it are themselves historical and have sometimes been too readily embraced as congruent to our own.[3] He nowhere set out to account for problems of time alone, conceived apart from history or experience, and it demands stealth and tact to approach the subject and to reconstruct what one can of his thinking on it. While he treated memory and experience more extensively, it is hard and not always desirable to abstract an understanding of time from these terms. As a preliminary to the subject I want to compare some passages from his second published work, *One-Way Street*, on the subject of waking, then to proceed to his tantalising references to ritual in the essay *On Some Motifs in Baudelaire*, before finally coming to some of the theses in *On the Concept of History*.

The subject of 'qualitatively distinguishable times' will tend to slide away from us as it is very hard to excerpt in utilitarian fashion from Benjamin's work without being drawn into explanations of its particular philological and interpretative difficulties. Benjamin is best approached by putting aside any idea of the immediate utility of his work to theory, politics or aesthetics and, after sustained

engagement with the work and its language, by letting its structures apply themselves to present problematics, when or if they will. His thought is condensed in its expression, oblique, and easily betrayed.

While no one who reads Benjamin at any length can fail to sense that his work does have a bearing on political questions about the development of societies and the nature of modern experience at the deepest levels of our subliminal being, one of the qualities of the work is its slowness. Paul Connerton insisted, at a time when Benjamin was still being yoked to present-day political questions rather crudely, that Benjamin

> knew the experience of slowness, what might even be called an obstinate weight and haul of slowness, and he meditated on the question—a question grown more urgent even in our lifetime than in his—of the ways in which, somehow, renewed access might be found to a proper slowness, to a pulse beating without haste but with a fullness of life.[4]

This slowness appears in an early examination of the relationship between dream and waking in *One-Way Street*, which I shall quote in full:

BREAKFAST ROOM

A popular tradition warns against recounting dreams on an empty stomach. In this state, though awake, one remains under the sway of the dream. For washing brings only the surface of the body and the visible motor functions into the light, while in the deeper strata, even during the morning ablution, the grey penumbra of dream persists and, indeed, in the solitude of the first waking hour, consolidates itself. He who shuns contact with the day, whether for fear of his fellow men or for the sake of inward composure, is unwilling to eat

and disdains his breakfast. He thus avoids a rupture between the nocturnal and the daytime worlds—a precaution justified only by the combustion of dream in a concentrated morning's work, if not in prayer, but otherwise a source of confusion between vital rhythms. The narration of dreams brings calamity, because a person still half in league with the dream world betrays it in his words and must incur its revenge. Expressed in more modern terms: he betrays himself. He has outgrown the protection of dreaming naïveté, and in laying clumsy hands on his dream visions he surrenders himself. For only from the far bank, from broad daylight, may dream be recalled with impunity. This further side of dream is only attainable through a cleansing analogous to washing yet totally different. By way of the stomach. The fasting man tells his dreams as if he were talking in his sleep.[5]

In this passage, slowness, domestic ritual and habit are presented as a kind of religious observance, which keeps the 'vital rhythms' of sleep and waking life separate, but not forgetful of each other: neither dream nor waking should be feared. It is striking that Benjamin, the translator of Proust, does not offer this bourgeois ritual as a solipsism, as a matter for one life only; neither does he tell us a dream. He offers us an exemplary pattern of behaviour. The urgency with which the writing asks us to consider these matters alerts us to the fact that this is more than an attempt to 'preserve' a bourgeois pattern or, indeed, a surviving popular tradition.

The idea of an exemplary mastery of sleep and waking returns with greater urgency and force at the end of the book, in a fascinating disquisition on fortune-telling, 'MADAME ARIANE: SECOND COURTYARD ON THE LEFT'. Here the idea of mastery appears in the context of Benjamin's interests in the practices and bodily observances of religion, which he appears to regard as of greater signifi-

cance for a secularising world than the transmission of doctrines as such.' In just such mastery the ancient ascetic exercises of fasting, chastity and vigil have for all time celebrated their greatest victories. Each morning the day lies like a fresh shirt on our bed; this incomparably fine, incomparably tightly woven tissue of pure prediction fits us perfectly. The happiness of the next twenty-four hours depends on our ability, on waking, to pick it up.'[6] The danger that we may fail to 'turn the threatening future into a fulfilled now' is present, but it can be averted by practice and 'bodily presence of mind'. Slowness and correct preparation are necessary, but there is also an undoubted sense of crisis-time, *kairos*.[7] Our lives offer us particular moments of decision and crisis where we must trust to courage and action.

It is perhaps a surprise to find moral and experiential *exempla* of this kind in a book that is often regarded as the high point of Benjamin's modernism; likewise to find such a prevalence in it of an enthusiasm for religious practices, however oblique. What *One-Way Street* does not do, though it indicates the topography of the problem, is to provide an account of the relationship between the personally experienced though somehow generic crisis-times and the collective crisis, the shadow over the future tense felt during the years of the German Inflation in which the book was written.

Benjamin never clearly resolved how he saw the relationship between individual and collective action, between personal and collective memory. But at the points where he expresses his differences with Proust, the lineaments of the problem become clear. In the essay *On Some Motifs in Baudelaire*, Benjamin draws on Proust's private archaeology of the crisis of experience, quoting his view that the past

is somewhere beyond the reach of the intellect, and unmistakably present in some material object (or in the sensation which such an object arouses in us), though we have no idea which one it is. As for that object, it depends entirely on chance whether we come upon it before we die or whether we never encounter it.[8]

The *mémoire involontaire* has the force of the dream remembered startlingly from the clear side of daylight. But Benjamin cannot allow himself to agree with Proust on the element of pure chance involved, because, for the social theorist, the crisis of experience must be lifted from its location in the narrative of an individual life, and the moments of possibility generalised.

According to Proust, it is a matter of chance whether an individual forms an image of himself, whether he can take hold of his experience. It is by no means inevitable to be dependent on chance in this matter. Man's inner concerns do not have their issueless private character by nature. They do so only when he is increasingly unable to assimilate the data of the world around him by way of experience.[9]

What Benjamin means by experience, and the variously described crisis, decay or atrophy of experience, need some explanation. It can be best examined by reading Benjamin's essay *The Storyteller*, which should be the starting point for any encounter with this author. He makes a contrast between storytelling, the form in which it had been possible to exchange experience, to give counsel; and information, its opposite. The story bears the marks of all those who have told it and passed it down; it is implicitly a bond to the dead generations and to the living circle of listeners. The familiarity with death shown by the story in the mouth of the storyteller is a bond to the

collective, which for Benjamin is nearly always a place of warmth. He liked to quote the Roman phrase for dying *ad plures ire*, going to the many. In opposition to storytelling is information, characterised by the newspaper (principles: 'freshness of the news, brevity, comprehensibility, and, above all, lack of connection between the articles'). On the other hand:

> It is not the object of the story to convey a happening *per se*, which is the purpose of information; rather, it embeds it in the life of the storyteller in order to pass it on as experience to those listening.[10]

To return to Benjamin's differences with Proust. While he charts the magnificence of Proust's attempt to command experience in the form of memory, he states that the isolated individual's attempt to resurrect the past through the *mémoire involontaire*

> bears the marks of the situation which gave rise to it; it is part of the inventory of the individual who is isolated in many ways. Where there is experience in the strict sense of the word, certain contents of the individual past combine with material of the collective past. The rituals with their ceremonies, their festivals (quite probably nowhere recalled in Proust's work), kept producing the amalgamation of these two elements of memory over and over again. They triggered recollection at certain times and remained handles of memory for a lifetime.[11]

This excursus into commentary has now brought us to a crux: the form of ritual in which certain contents of the individual past combine with those of the collective past. Rituals are 'qualitatively distinguishable times' par excellence.[12] They occur at prescribed times, normally in

special places or in places that are transformed for the participants by ritual action. Ritual has been defined as a 'rule-governed activity of a symbolic character which draws the attention of its participants to objects of thought and feeling which they hold to be of special significance.'[13] Rituals were also of prime significance in the development of calendars and in the development of accurate timekeeping, though their understanding of time is so opposite to the spirit of the stopwatch. Mass, for example, is a re-enactment of the last supper, whether held to be symbolic or actual, that fills the present with the reverberations of an originary now.

In the period of Benjamin's lifetime rituals had been widely investigated and studied as 'survivals' of supposed earlier patterns; in part, this study was itself a sign of a growing estrangement from tradition. Rituals had also been invented and reinvented at the highest levels in the European national calendars, along with other aspects of tradition.[14] It is somewhat frustrating that Benjamin did not find it necessary to say what he meant by ritual. At brief moments in the Baudelaire essay, Benjamin appears to admire the potential of ritual to replenish the fullness of time: and collective life.

More characteristically, however, his subject is the emptiness of time, from which the *mémoire involontaire*, or the Baudelairean *correspondences* must be won, as and when it offers itself. Benjamin defines *correspondences*, frustratingly briefly, as 'an experience which seeks to establish itself in a crisis-proof form. This is possible only within the realm of ritual.'[15] Benjamin nowhere directly states whether he thought this realm of ritual might be recovered, but his condemnations of empty time threaten to summon up ritual's fullness by the force of the negative. As the 1930s wore on, perhaps positive speculation

in the area of ritual curtailed itself. National Socialism subsumed the area where national ritual might have existed, in its displays and use of spectacle.[16]

So the path to a sense of 'good' ritual was blocked. Benjamin's understanding of melancholy and his arguments with it are complex; he left few clues that behind it was a wish for happiness.[17] Happiness was more easily grasped in its negative image, in the writings of Baudelaire, than in the sanguine believers in progress that Baudelaire, like Benjamin, attacked. The temporal characteristics of this melancholy, unstructured by ritual, are perhaps paramount. Life becomes something measured in minutes and seconds, quantitatively. The flow of minutes and seconds succeeds in freezing the quick:

> *Et le Temps m'engloutit minute par minute,*
> *Comme la neige immense un corps pris de roideur.*

Benjamin comments: 'in the *spleen* the perception of time is supernaturally keen: every second finds consciousness ready to intercept its shock.'[18] And yet the question is never the false alternatives of quality or quantity, but of an emptiness that yet permits moments of possible recuperation:

> Even though chronology places regularity above permanence, it cannot prevent heterogeneous, conspicuous fragments from remaining within it. To have combined recognition of a quality with the measurement of the quantity was the work of the calendars in which the places of recollection are left blank, as it were, in the form of holidays. The man who loses his capacity for experiencing feels as though he is dropped from the calendar. The big-city dweller knows this feeling on Sundays.[19]

By the time Benjamin wrote the theses entitled *On the Concept of History,* all speculation was conducted under the sign: crisis. These unpublished texts, written after the Molotov-Ribbentrop pact, have been the focus of much interpretative activity and also of much dissent. They ask us to decide to what extent Benjamin is arguing with the Social Democratic Party, the inheritor of the nineteenth-century ideology of progress, and to what extent with fascism. They also present the problem of violence, revolutionary and otherwise: we must decide to what extent Benjamin's understanding of crisis justified an answering holy violence; and whether this violence might have been otherwise conceived, or based on a different and less harsh conception of law.[20]

Having gestured towards these problems, I wish to examine how Benjamin's conception of time seems to have developed before his work was broken off. In some respects it seems absolutely consistent with the emphasis already found in *One-Way Street* that there are particular moments right and ripe for remembrance, that must be grasped, now, not by bodily presence of mind alone but by collective, historical presence of mind:

> The true picture of the past flits by. The past can be seized only as an image which flashes up at the instant it can be recognised and is never seen again. 'The truth will not run away from us': in the historical outlook of historicism these words of Gottfried Keller mark the exact point where historical materialism cuts through historicism. For every image of the past that is not recognised by the present as one of its own concerns threatens to disappear irretrievably...[21]

Against the deadening positivistic narrative of German historicism Benjamin presents a vital and seemingly

impossible duty. It is important to recognise the unclarity of Benjamin's point here, in the text that has come down to us, never published by him. Is this the duty of historical materialists or the proletariat? At crucial points one has to note the failure of Benjamin to locate his sense of crisis in a theory of action, or to relate individual to collective action. And to note that the argument with Proust is not after all completed: it seems unbearably too close to chance, whether the image of the past here will be recognised or slip away. Benjamin equivocates on the question of whether the image can be summoned or grasped at a moment of danger, between voluntary and involuntary memory.

In *Thesis XV*, Benjamin's conception of the time following revolution combines violence with remembrance of the French revolution:

> The great revolution introduced a new calendar. The initial day of a calendar serves as a historical time-lapse camera. And basically, it is the same day that keeps recurring in the guise of holidays, which are days of remembrance. Thus the calendars do not measure time as clocks do.[22]

But this remembrance of the reverberations of the day of revolution appears elegiac. The means to collective remembrance, to any ritual or holiday that might be conceived good, to collective regularities, are blocked by fascism, and as Gillian Rose argues, by the particular aspects of Jewish law that infuse Benjamin's thought, which lacks a Day of Atonement.

The critique of progress might be considered at one remove from these questions, even if it cannot be sundered from them. It was the theme Benjamin pursued with brilliance in mostly unpublished texts, that may be

compared with Adorno's later essay, 'Progress'.[23] In *Thesis XIII*, headed with a quotation from Dietzgen's *Die Religion Der Sozialdemokratie*, 'Every day our cause becomes clearer and people become smarter', Benjamin reaches a newly clarified objection to 'homogeneous empty time' as the foundation of his critique of progress. Having criticised several predicates of Social Democratic thought, Benjamin states:

> Each of these predicates is controversial and open to criticism. However, when the chips are down, criticism must penetrate beyond these predicates and focus on something that they have in common. The concept of the historical progress of mankind cannot be sundered from the concept of its progression through a homogeneous, empty time. A critique of the concept of such a progression must be the basis of any criticism of the concept of progress itself.[24]

'Homogeneous, empty time' is time unstructured by exemplary recurrence, by celebration, and recognises only the relationships 'Progress' blandly conceives between stupider and cleverer, earlier and later, primitive and developed; and we might add, novel and outmoded. This is perhaps where our sense of qualitatively distinguishable times has changed at the deepest levels, under the influence of the rhythms of commodity production. It is also a point where we can, without misremembering the genesis of Benjamin's arguments in his understanding of Social Democracy and fascism, perhaps recognise the far-reaching clarity of his understanding of the experience of time and capital, which lights up for us even the very changed circumstances of our experience across a fifty-year gap.

Developed with a different emphasis, Paul Connerton's

work—on the role of bodily performances and commemorative ceremonies in the transmission of collective memory—continues the work of reasoned hostility to the deeper implications of capital and progress:

> Capital accumulation, the ceaseless expansion of the commodity form through the market, requires the constant revolutionising of the innovative into the obsolescent. The clothes people wear, the machines they operate, the workers who service the machines, the neighbourhoods they live in—all are constructed today to be dismantled tomorrow, so that they can be replaced or recycled...the temporality of the market and of the commodities that circulate through it generates an experience of time as quantitative and as flowing in a single direction, an experience in which each moment is different from the other by virtue of a coming next, situated in a chronological succession of old and new, earlier and later. The temporality of the market thus denies the possibility that there might co-exist qualitatively distinguishable times, a profane time and a sacred time, neither of which is reducible to the other. The operation of this system brings about a massive withdrawal of credence in the possibility that there might exist forms of life that are exemplary because prototypical. The logic of capital tends to deny the capacity to imagine life as a structure of exemplary recurrence.[25]

'Forms of life that are exemplary because prototypical'; as Benjamin had sensed, the identification of money and time denies life such exemplary forms:

> Beyond doubt: a secret connection exists between the measure of goods and the measure of life, which is to say, between money and time. The more trivial the content of a lifetime, the more fragmented, multifarious, and disparate are its moments, while the grand

period characterises a superior existence. Very aptly, Lichtenberg suggests that time whiled away should be seen as smaller, rather than shorter, and he also observes: 'a few dozen million minutes make up a life of forty-five years, and something more.' When a currency is in use a few million units of which are insignificant, life will have to be counted in seconds, rather than years, if it is to appear a respectable sum. And it will be frittered away like a bundle of bank notes. Austria cannot break the habit of thinking in florins.[26]

The acute time-consciousness that we have continued to develop since Benjamin's era does not always appear to us directly as the identification of the measure of money and the measure of time. It takes place at such a habituated level that time has a status in our consciousness as a determining force all of its own.[27] Nations negotiate across barriers and qualitatively distinguishable habituations to time, which may or may not be different stages of qualitative development or progress in civilisation. The regime of hard work and passive entertainment, in which prototypical forms of life and exemplary patterns of recurrence are frustrated and denied, is one such notion of 'development' that might be questioned. While it is not here denied that development has taken place, and that it should take place, the ultimate role of scrupulously monitored attention to time in it—and its relation to happiness and to fullness of time—is unclear. Perhaps to ask these questions, in the spirit of Benjamin's critique of the ideology of progress, is to approach an understanding of the realm of habit in which our valuations of earlier and later, more and less developed, seem to inhere.

Notes

This essay is extensively revised from notes for a lecture in the spirit of what I intended to say at the time. I would like to thank in particular Jenny Uglow, David Harding, Rabhya Dewshi and Simon Jarvis.

1 Norbert Elias, *Time: An Essay*, translated by Edmund Jephcott, Oxford, 1993.
2 *Lichtenberg: Aphorisms and Letters*, translated and edited by Franz Mautner and Henry Hatfield, London, 1969, p.49.
3 This is particularly the case in art colleges where the main text studied—often in isolation—is 'The Work of Art in the Age of Mechanical Reproduction', *Illuminations*, translated by Harry Zohn, New York, 1969.
4 Paul Connerton, *The Tragedy of Enlightenment: An essay on The Frankfurt School*, Cambridge, 1980, p.14.
5 Walter Benjamin, *One-Way Street and Other Writings*, translated by Edmund Jephcott and Kingsley Shorter, London, 1979, pp.45–6.
6 Ibid., pp.98–9.
7 On the distinction between *kairos* and *chronos*, see Frank Kermode, *The Sense of an Ending: Studies in the Theory of Fiction*, New York, 1968, ch.2: '... Hebrew...had no word for *chronos*, and so no contrast between time which is simply "one damn thing after another", and time as concentrated in *kairoi*.'
8 Quoted in Walter Benjamin, 'On Some Motifs in Baudelaire', *Charles Baudelaire: A Lyric Poet in the Era of High Capitalism*, translated by Harry Zohn, London, 1973, p.112.
9 Ibid., p 112.
10 Ibid., p.112.
11 Ibid., p.113.
12 The phrase is Paul Connerton's, from *How Societies Remember*, Cambridge, 1989.
13 Ibid., p.44, quoting Lukes.
14 Benjamin's anthropological reading is not entirely clear. But see Axel Honneth, 'A Communicative Disclosure of the Past: On the Relation between Anthropology and Philosophy of History in Walter Benjamin', *New Formations*, 20, 1993, pp.83-94.

15 Op.cit., *Baudelaire*, p.140.

16 Though we should note that however powerful National Socialist ritual may have been, it was filledness, amnesiac obliteration: in Benjamin's terms, it is for people who are losing the capacity to experience, as its kitschy mythic 'memories' demonstrate. The historian Marc Bloch wrote in 1940, probably in response to Georges Dumézil's analysis of the use of pre-Christian myths and symbols under the Third Reich, that 'by virtually abandoning those national rituals that exalted and united the people, the Third Republic had "left it to Hitler to revive the paeans of the ancient world."' Bloch, the assimilated Jew and French patriot, was aggrieved that forms for an appropriate national ritual had not been developed. Carole Fink, *Marc Bloch: A Life in History*, Cambridge, 1991, p.194.

17 'Happiness': See Walter Benjamin, 'Theses on the Philosophy of History', *Illuminations*, pp.253-4. For melancholy see Walter Benjamin, *The Origin of German Tragic Drama*, translated by John Osborne, London 1990, and 'Left-Wing Melancholy' *Screen*, 15, 2, pp.28–32. On aberrated mourning in Benjamin, see Gillian Rose, *Judaism and Modernity: Philosophical Essays*, Oxford, 1993, ch.12.

18 Op.cit., *Baudelaire* p.143.

19 Ibid., p.144.

20 See Rose, op.cit., ch.12.

21 *Illuminations*, op.cit., p.255.

22 Ibid., pp.261–2.

23 Walter Benjamin, 'N [Re the Theory of Knowledge, Theory of Progress]', translated by Leigh Hafrey, Richard Sieburth; Theodor W. Adorno, 'Progress', translated by Eric Krakauer; both in Gary Smith (ed.), *Benjamin: Philosophy, Aesthetics, History*, Chicago and London, 1989.24 *Illuminations*, pp.260–1.

25 Paul Connerton, *How Societies Remember*, op.cit., pp.64–5.

26 *One-Way Street*, op.cit., p.96.

27 See Elias, op.cit., p.118; see also Michael T. Taussig, *The Devil and Commodity Fetishism in South America*, Chapel Hill, 1984, p.5: '... Moreover, [time] is animated: so we speak of fighting against it. Time becomes a thing abstracted from social relations because of the specific character of those social rela-

tions, and it also becomes an animated substance....I take it to be a particular illustration of commodity fetishism, whereby the products of the interrelations of persons are no longer seen as such, but as things that stand over, control, and in some vital sense even may produce people.'

8
Eight Berlin Landmarks

RICHARD WENTWORTH

Bayerischer Platz, 1993

Flottwellstrasse, 1993

Krausenstrasse, 1993

Mariannenplatz, 1993

Helmstedter Strasse, 1993

Adalbert Strasse, 1993

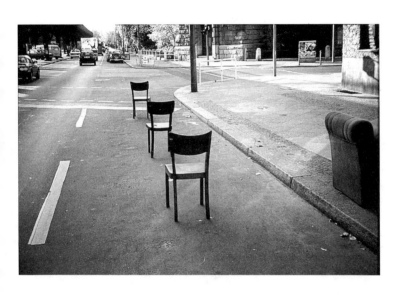

Sigismundstrasse, 1993

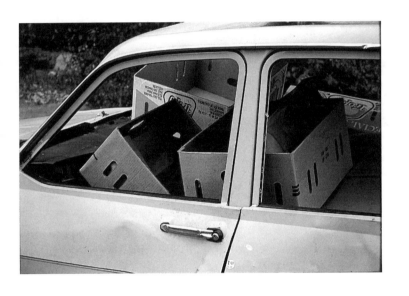

Gitschinerstrasse, 1993

9
The Dream and the Word

SUSAN HILLER

I've tried to figure out ways to talk about work, my own work, that don't give the impression that it's already used up and completed? I am trying to find a way to talk about work that gives me a chance to learn something through talking about it.

We seem to have come to a situation in the history of art where sometimes the custom of artists talking about their work has become more important than the work itself, and I feel this is a very dubious kind of practice. I want to stress that my talking about my work is tentative and that thinking is in progress. And that if there is any final point of reference, it is always the work. The emphasis is on the performative aspect of art, that is, the interrelationship between the work—whether it's an object or an event—and the viewer, who is a participant in the work. 'The work' includes the viewer, who is the medium through which 'meaning' is attributed or created. 'The work' is the best evidence of what the artist or the art practice is about.

I consider my approach to be evocative rather than instructive, and what I'm saying is really intended as an evocation of a set of ideas.

I would like to open by locating the places where certain tendencies within my practice might find their roots or beginnings. To lead up to these originating points, I need to set the scene by going back to some of the things I was thinking about in the 1970s. I'm going to tell you a story that situates the questions I was engaged in then, although I only heard the story recently. I got it from an American poet who got it from an anthropologist who got it from the autobiography of another anthropologist.[1] This story has particular resonance for me because I used to be an anthropologist. I also think it has a lot of relevance to art, to the relationship between practice and theory in art, to making work and talking about it, to thinking about the dream and thinking about the word...

The story concerns someone called Maurice Leenhardt, who in the 1930s was visiting the New Caledonians, the host people he was going to study. But in this particular instance, instead of the anthropologist asking the natives questions, they asked him questions. And they came to him in a rather formal delegation and said, 'Where does the wisdom of white people come from?' and he said, 'It comes from observation, free from superstition.' They thought that he had not understood their question. So they said to him, 'Where does the original idea of a thing come from?' And he said, 'I suppose you think it comes in a dream, the way your forefathers discovered a magic stone in a dream.' And they answered, 'Yes' and left it at that.

Now the New Caledonians are asking the ethnographer a very searching question, an epistemological question, which he is apparently unable to answer, except by assuming that, because his own world-view is superior to theirs, they will not understand it, and so he must answer in their own terms, which they will understand, and

which of course he also fully understands. His view comes from pure observation, free from superstition, and theirs come from superstition. But they ask him in return, 'Where does your whole concept of knowledge come from?' And he can't answer that, so he says, 'Well, I suppose you people think it comes in a dream, the way your superstitious concept of knowledge comes in a dream.' And they go, 'Uh-huh...' which is the end of the conversation. This story addresses the polarity between what we might call 'the word' and 'the dream', between theory and practice.

The anecdote triggered off a series of uncomfortable associations in me, not all of which are simply negative reactions to its colonialist geopolitical aspects. It reminded me of Maya Deren's astute comment that artists in Western society are always in some sense 'the natives', since they are treated as subject matter by critics and theorists, and as providers of raw materials for markets. And that led me to recall Sigmund Freud's early description of his own project as 'reclaiming territory from the primordial chaos of the unconscious mind', with its echoes of the whole colonialist mentality and culture-bound assumption shared with Leenhardt, of a hierarchically superior position assigned to a certain kind of knowing which is equated with something called rationality.

Freud saw both art and dream as manifestations of the unconscious, and/or presentations of neurotic symptoms. In what has always struck me as a rather peculiar scenario, the artist is somehow only a naïve bystander in the process of producing an artwork. The artist has, according to Freud, a certain 'flexibility of repression'—that is, a fairly limited freedom to step aside and relax the control of his or her ego so that unconscious contents may emerge. The artwork illustrates or exemplifies the uncon-

scious fantasies, desires, etc. of the artist by the same means used in dreams to disguise unconscious meanings from the dreamer/artist. The artist's production of work is, like the dream, an untheorised, unauthorised, almost unintelligent symptomatology whose meaning is unknown to the artist. Someone else must provide the key to the work.

There is an exact parallel here with Leenhardt's dismissal of the indigenous epistemology of the New Caledonians as 'superstition'. I don't think it is unfair to describe this process as a form of colonialism. Someone discovers someplace new, someplace he's not been before. But for the people living there, it isn't a new place. Through this encounter, reciprocally, the power relationship which is established determines a hierarchy of value. The anthropologist 'discovers' the natives and 'discloses' their meanings. The natives' meanings are superstitious and irrational, or they are neurotic symptoms. In any case, they are not as rational, or profound, or overarching as the meanings of the explorer/psychoanalyst/anthropologist/art theorist, which can 'explain' and replace them.

Clearly, something is very wrong with accepting this relationship. Perhaps only we 'natives' can see what it is.

In the most basic sense, we could say that a great many societies, like ours, find their point of origin in the word: 'In the beginning was the word, right?' But just as many have their point of origin in the dream: 'In the beginning, was the dream.' Now, what's the difference between the word and the dream? Well, we know that there's a difference between words and dreams in our own society. We relegate dreams to unreality, until they become texts which can be told in words, for diagnostic purposes. In our society words give meaning to dreams. It seems to me

that if we could locate our own way of looking at dreams, not as hierarchically superior to the ways of others— unlike Leenhardt who assumed that he had a rational metaposition that encompassed the superstitions of the New Caledonians—but simply as being one way, on a par with others, discarding our assumption of cultural supremacy for a minute, we might see that our ideas about dreams are entirely culture-bound as Leenhardt's idea of knowledge was. We simply *assume* that theory is more profound, more intelligent than experience, and that words are the proper vehicle for understanding dreams. But this may well not be the case. As an artist, I argue that dreams, and art, and words, are places where behaviour occurs rather than representations or illustrations.

Using theory to understand art is as odd as it would be to use dreams to understand theory, or art to understand dreams. In other words, I'm interested in questioning, problematising, the hierarchies that seem self-evident within our culture. To extend this claim, I will reflect on some images which are about the way certain earlier artists in Western society have represented dreams visually.

First, an engraving by Grandeville, a nineteenth-century French engraver, much appreciated later on by the Surrealists. Grandeville in fact committed suicide, I believe, shortly after making this illustration. Here, Grandeville seems to be accepting that the narrative structure of the dream is constructed afterwards, like a story with a beginning, a middle, and an end. Grandeville is showing a number of stages or incidents to the dream, and you can see or read this very clearly. You can see his sense of guilt, in fact a kind of sexual guilt. The dreamer

'Crime and Punishment', wood engraving after J.J. Grandeville, published posthumously in *Le Magasin pittoresque*, France, 1847

is portrayed as fleeing from a giant eye, a pun of course, the relentless superego. He falls into the sea, where he finds himself clutching the cross while pursued by a dreadful sea monster—the battle continues in the unconscious. It is all quite beautifully illustrative of nineteenth-century dream imagery, I think. The cross at the bottom is intended as a symbol of salvation, and apparently the

artist's suicide was due to his despair at his inability to accept the power of conventional Christianity to save him from his guilt. There are two main issues; first, the legibility of these images—we know what they mean, we can read them—and second, the artist's acceptance of a narrative structure of the dream, which he depicts in an almost filmic, episodic way.

The next image is by William Blake, a little study, almost a sketch, of a dreamed room. This is more artefactual than Grandeville; it has the sketchy look of immediate notes on a dream or vision, rather than a revised version. The fact that there are contradictory perspectives—a space within a space-may well be one of the important issues in the work. Another interesting thing is the unresolved quality

Drawing, William Blake, England, early nineteenth century

of the central figures, which appear to be somebody writing or drawing at a table, with a larger somebody standing over, with a light source like a halo above. The sentence at the bottom wasn't written by Blake but by a friend of Blake's who annotated his estate after his death. It says: 'I suppose this to be a vision, indeed, I remember a conversation with Mr Blake about it.'

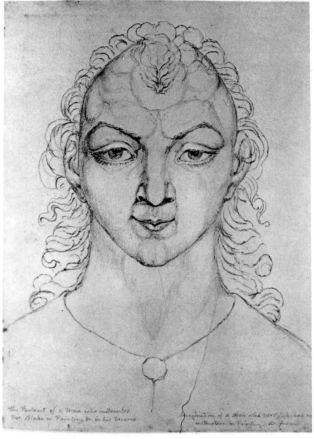

Pencil drawing, William Blake, England c. 1819

This better known Blake drawing, like the Grandeville, has the quality of a conscious artwork, in the sense that it has been clearly reworked. It exists in several versions, very different from the sketch of the little room. It is possible that this portrait, entitled by Blake's executor, 'The Man Who Taught Mr Blake Painting in His Dreams' could be, in fact, a secondary elaboration of the figure standing over the seated somebody in that sketchy little study. It is worth noting that we recognise what we are seeing. There is a mythical being, a person with a third eye, drawn in detail, depicted conventionally, just like something in the waking world of consensus reality, no problem in recognising it as a representation.

The combination of image and word in this page from Dürer's notebooks is an important aspect from my perspective. It is artefactual or documentary. As Dürer told it, his dream was of a great fall of water from heaven onto earth. His text tells how frightened he was so that the next

Notebook page, Albrecht Dürer, Germany, 1525

morning, as soon as he got up, he made these notes and the drawing. His use of the two forms of designation means that there is something missing at the centre, a sense of missing insider information. Blake felt he understood the meaning of his dreams, Dürer didn't. We are confronted by a picture and a set of words, and we still do not know what disturbed the artist because he did not know himself. In medical terminology, this is what is known as a prodromic dream, a dream that predicts or diagnoses a specific physical condition or disease, like a woman dreaming of a red flower just before her menstruation begins.

Next, a set of little coloured drawings from the notebooks of Hervey de Saint-Denis, who, in the nineteenth century, decided to study his dreams in detail in order to develop the capacity for lucid activity during sleep. The kind of consciousness that interested him involved being

Frontispiece of *Les rêves et les moyens de les diriger* by the Marquis d'Hervey de Saint-Denis, France, 1867

able to become fully aware that he was dreaming while dreaming, in order to move volitionally through the dream world. Hervey de Saint-Denis combined dream theories from exotic societies, perhaps derived from yogic practices, with nineteenth-century Western empiricism regarding inner states. These are images of hypnagogic visions, visual notations or representations of what you might see just before falling asleep, those sparkly bits and bright colours you sometimes see while lying in bed with your eyes shut. Hervey de Saint-Denis made hundreds of these documentary drawings of what he called 'wheels of light, tiny revolving suns, coloured bubbles rising and falling ... bright lines that cross and interlace, that roll up and make circles, lozenges and other geometric shapes.'

This is a late twentieth-century attempt to represent visually the same hypnagogic imagery by someone who was interested in mystic states, in the context of a set of doctrines and instructions derived from Buddhism and Hinduism. Here the subjective, abstract and uncodified light effects are seen as opportunities to experience a profound visionary illumination. I will not elaborate on the meditation exercise which these diagrams illustrate, except briefly to list the stages of seeing that are relevant. First, not illustrated, looking into inner darkness; next, sighting the bright shapes so carefully diagrammed over many years by Hervey de Saint-Denis, and concentrating on the bright fragments appearing against a dark background, at which point the dark background is said to disappear entirely. The final stage in which the coloured fragments and shapes give way to a pure white light is also not illustrated. (You might like to try this exercise for yourself.)

The most intriguing approach to dreams in modern art is not, to my way of thinking, Surrealist painting with its

Cover illustration, 'The Astral Light' from *The Art and Practice of Astral Projection*, Ophiel, USA, 1961

rebus-like homage to Freud's equation of dream imagery with word-play. Instead, I am more inspired by this painting by Miró. It labels itself a photo in old-fashioned calligraphy, and says that it depicts a dream colour. Taken as a whole, the painting may be ironic, it may be a joke, or it may be meant very seriously indeed as documentation, like Hervey de Saint-Denis's drawings. In any of these cases, the artist would be commenting, very intelligently, on dream theory, by contrasting what the modern medium of photography and the traditional medium of painting can each achieve in documenting, illustrating, or evoking dreams.

This is quite different, but equally analytic. It's by Giacometti, a series of precise diagrammatic drawings that record and investigate a troubling dream. It becomes a map or, as I sometimes think of it, a sketch for an installation. Giacometti says: 'I saw my design turn into an

'Photo that is the colour of my dreams', Joan Miró, 1925

Alberto Giacometti, 'The Dream, the Sphinx and the Death of T.', first published in *Labyrinthe*, ed. Albert Skira, No.2, Switzerland, 1946

Photomontage illustrating 'The Dream Machine', Brion Gysin and Ian Sommerville, *Olympia*, No.2, France, 1962

object...with immense pleasure I imagined myself walking on this disk and reading the story before me'. The everyday world of 'real' events would be glimpsed between panels representing specific dream scenes—an ever-changing sequence of relationships between dream-life and life in the waking world.

'The Dream Machine' is a simple revolving cardboard cylinder with a lightbulb at the centre. Light emerges through configurations of slots and holes cut in the cardboard. The purpose of the machine is to stimulate imagination, image-formation, and visionary experience.

> Maximum effect is achieved with a light of at least 100 watts when flicker plays over closed lids brought as close as possible to the cylinder The effects ... continue to develop over a long period of time In the bigger machines...whole moving pictures are pro-

duced and seem to be in flux in three dimensions on a brilliant screen directly in front of the eyes.

With this cursory look at certain Western dream images, we have glimpsed some relationships between words and dreams. With the exception of the Dürer, Giacometti and Miró we have been looking at pictures not words. Nevertheless, I have emphasised the legibility of the images, which underlie their potential to be understood not just for personal or symbolic content but as insights about mental structures and the place of dreams in specific historical era. It is possible to see them as diagrams or maps which are as accurate and insightful about the mind as theory is. These dream representations fall roughly into three categories: the *illustrative* or descriptive, which picture or illustrate dream imagery of a more-or-less conventional kind; the *documentary* or artefactual, which attempt to achieve a kind of accurate reportage; and the *evocative*, which are meant to trigger off an experience similar to a dream. And sometimes there are intelligent combinations of these possibilities, as in the Miró painting. These artworks are as clear, as informed and as adequate in conveying a range of theoretical options and insights about dreams as contemporary texts were in different historical periods.

Several of my own works of the 1970s and 1980s were examinations of the dualism we set up between words and pictures, using dreams and dream imagery as basic materials. *Dream Mapping* and *The Dream Seminar* were investigative works made with groups of people, and eventually led to the solo works, *Bad Dreams, Lucid Dreams*, and all the works I have made using automatism, starting with *Sisters of Menon*.

Throughout all this work I have been convinced that

illustrating dreams or describing dreams would be too limiting, with the increasing insistence on a codification of meaning and the correctness of certain theoretical approaches towards dreaming (the *Dream Police* is the name of a work I never made). Our society has given birth to an academic superego determined to repress individual dreams at the same moment as certain theories about dreams are dominating art criticism, literature, etc. As dreamers and artists, we need to retain a sense of humour while noticing how psychoanalysis is being increasingly 'used' to establish positions where experts in theory can 'understand', on behalf of practitioners, who are supposed not to understand. This old split between the ethnographer and the natives keeps coming back again and again. But the natives, ourselves, the artists who used to be experts in imagination and dream, do not seem to play this game as well as we might, not nearly as well as the New Caledonians, who knew how to ask a hard question.

I want to emphasise, again, that I have stumbled across these insights in the process of making the works I've mentioned, as well as other works, like *Sometimes I Feel Like a Verb Instead of a Pronoun*. I did not start off with a notion or theory I wished to illustrate. From the beginning of the 1970s onwards I was interested in visual ways of communicating dreams,[2] and research into this, combined with my personal predilections and experiences, are the roots of these thoughts. I am interested in creating a situation where through my work such things can distil out or clarify, making a new kind of sense both to me as the instigator and to other people who establish the meaning of the work, that is, the audience.

My work takes the degree of lucidity I have found through my interest in dreams as the starting point for a

Belshazzar's Feast, Susan Hiller, 1983–4, 20-minute video programme, col. Tate Gallery, London; illus. large bonfire version, *La Ferme de Buisson*, Paris 1993

shared comprehension. *Belshazzar's Feast* is structured to provoke or seduce the viewer into an increased awareness. It is not a dream, or even based on a dream, but it is a mirror or a proposition, a proposal, like a dream can be. And the image in this mirror should be clear, whether you read it as personal and private or social and collective.

Nowadays we watch television, fall asleep, and dream in front of the set as people used to by their fireplaces. In this video piece, I am considering the TV set as a substitute for the ancient hearth and the TV screen as a potential vehicle of reverie replacing the flames.

Some modern television reveries are collective. Some are experienced as intrusion, disturbances, messages, even warnings, just as in an old tale like Belshazzar's Feast, which tells how a society's transgressions of divine law was punished; advance warning of this came in the form of mysterious signs appearing on a wall.

My version quotes newspaper reports of 'ghost' images appearing on television, reports that invariably locate the source of such images outside the subjects who experience them. These projections thus become 'transmissions', messages that might appear on TV in our own living rooms.

Like the language of the flames ('tongues of fire'), these incoherent insights at the margins of society and at the edge of consciousness stand as signs of what cannot be repressed or alienated, signs of that which is always and already destroying the kingdom of law.

Notes

This text is the edited transcript of an invitational lecture at Glasgow School of Art, 5 February 1993. Hiller's text was based on two earlier improvised slide presentations, 30 November 1992 at the Ruskin School of Art, Oxford, and 1 December 1992 at Chelsea School of Art, London.

1 See Barbara Einzig, 'Within and Against: Susan Hiller's Nonobjective Reality', *Arts Magazine*, 66:2, New York, October 1991, p.63. The citation is James Clifford, *Person and Myth: Maurice Leenhardt in the Melanesian World*, University of California Press, Berkeley, 1982.

2 See David Coxhead and Susan Hiller, *Dreams: Visions of The Night*, Thames and Hudson, London, 1989.

10

Whose Subject?

Identities in Conflict in South African Visual Culture

COLIN RICHARDS

> Sharing the fascination with difference that white
> people have collectively expressed openly (and at
> times vulgarly) as they have travelled around the
> world in pursuit of the Other and Otherness, black
> people, especially those living during the period of
> racial apartheid and legal segregation, have similarly
> maintained steadfast and ongoing curiosity about the
> 'ghosts', 'the barbarians', the apparitions they have
> been forced to serve.[1]

Questions of identity, questions raised by 'our' attempts
to forge identities for ourselves, to map 'our' place in the
world, are pressing and complex in contemporary South
Africa. Any construction, any location of identity involves
representation: both representation of so-called 'others'
and self-representation. Visual culture—with its entangle-
ments of image and discourse—self-evidently plays a sig-
nificant part in the activity of representation. Who actual-
ly controls the mode of production and dissemination of
the visual figures, the imagery which binds 'us' together,
which draws 'us' apart, which places and negotiates our
'difference', is of course a crucial political question.

It is probably easier now than before to concede that

representation, broadly speaking, has to do with forms and relations of power. It is easier now to see representation as not simply reflexive, but constitutive. Perhaps too easy. For in this very moment, this very 'postmodern' moment which has doubtless played its part in securing this ease, we need to be suspicious. We need, for example, to interrogate those fabulous and fashionable notions of simulation, of simulacra, currently abroad in cultural discourse.

We undoubtedly live through and by representations. They are, as Edward Said suggests in an interview with Phil Mariani and Jonathan Crary,[2] a form of human economy and as basic as language. There is simply no getting away from them. Incited and enticed, exhorted and engaged, we love and kill through and in the name of representation. But we need to be deeply concerned when acceptance of the intrinsic constructedness of representations and their constitutive inter- and intra-subjective ramifications (mis)lead us into a maze of confusions about what is real and rooted and what is not. Instead of being a source of empowerment and liberation such knowledge places us more at risk of being more effectively robbed of our power as agents in our own lives, our human fates and fortunes.

Identities and Identifications

There can probably be no question as to the critical and political complications entailed in addressing the relations between identity, subjectivity and representation.

In South Africa, the selectively blind Apartheid vision of culture and society, still very much with us, has been conditioned and regulated literally and metaphorically

by thinking in terms of black and white. This basic anti-pathy has reduced, ossified and mutilated our world—material and mental—immeasurably. It has stigmatised our bodies and paralysed our minds. It has shrunk the horizon of our cultural possibilities in ways we can still barely comprehend.

Yet within this apparently monolithic and homogenising antipathy is a motley collection of other points of difference, all of some service to those oppressive visions of 'separate development'. While cultural struggle continues across a broad front, its terms have necessarily shifted from the blunt demands of combat and resistance along sharply drawn battle-lines. Cultural forces are reorienting and being remobilised beyond the rather raw notion of 'culture as a weapon in the struggle' to a notion of culture as a mode, a process, of self-exploration, (re)differentiation, reconstruction and transformation. Critical *engagement* is displacing strategies of isolation and confrontation. This turn is currently being signalled by the insertion of a rather utopian notion—*ubuntu*—into our shared cultural lexicon. Jacob Zuma, for example, suggested that if

> culture be the soul of humanity it is through the universally recognised cultural value of *ubuntu* or generosity that we can appeal for universal love and tolerance.[3]

Perhaps it is here, in this rhetoric, that we might begin to glimpse something 'different', perhaps even some radical humanism.

An early sign of this generous, inquisitive and reflexive turn was Albie Sachs's plea for cultural openness and critical introspection in South Africa. Sachs, himself a victim

of state terror, was at the time speaking from within and to the broad liberation movement. Addressing a non-South African audience Sachs had this to say:

> You ... know who you are. Perhaps your artists have to explore underneath all your certainties, dig away at false consciousness. We South Africans fight against real consciousness, apartheid consciousness, we know what we struggle against. ... But we don't know who we ourselves are. What does it mean to be a South African? The artists, more than anyone, can help us discover ourselves.[4]

Culture is here taken as a site of and resource for 'self-discovery'. Culture, subjectivity and identity interweave; 'Culture is a very deep thing. It's about who we are. It's what we mean when we say we are South Africans.'[5]

The place of culture in processes of social transformation and forging identities presses many obligations and responsibilities on artists. This returns us to an earlier point. On a macro-social level both the struggle for liberation and the maintenance of the repressive status quo often was, and remains, cast in terms of nationalism, and within nationalism, ethnicity. The assertion of ethno-nationalist identities involve, amongst other things, achieving political goals; the getting and keeping power, mobilising a following 'through the idiom of cultural commonness and difference'.[6] Clearly tribal constructs and representations play a powerful part in mobilising ethnic and nationalist sentiment. The Grand Apartheid vision of largely white Afrikaner nationalism had selectively segregated ethnic groups each 'self-determining' into nationhood. African nationalism as embodied in various tendencies in the African National Congress and the spirit of pan-africanism of the Pan Africanist Congress

and the Azanian People's Organisation, obviously flatly challenged this.

It has been said that it would probably be easier to dig a hole in water than find common ground in the various nationalisms and ethnic constellations within South Africa and beyond. Powerful, if imaginary, ideas of nationhood and ethnicity often betray wishful thinking. As E.J. Hobsbawm observes, in quite another arena of ideological conflict, the

> appeal to the imagined community of the nation appears to have defeated all challengers. What else but the solidarity of an imaginary 'us' against the symbolic 'them' would have launched Argentina and Britain into a crazy war for some South Atlantic bog and rough pasture?[7]

Hobsbawm's characterisation of especially nationalist movements of the late twentieth century as 'essentially negative', 'divisive' or 'defensive reactions' may relate more to the former Apartheid state than the South Africa to be.

Narratives of nation remain privileged in South Africa and certain other parts of the world. This is surely not surprising given our history of internal and external exile, banishment and displacement. It is thus to be expected that South Africa figures as somewhat exceptional in a cultural discourse otherwise sceptical about nationalism. Edward Said, for example, writes 'except in cases of...Palestinians, South African Blacks, Puerto Ricans or Kurds, nationalism is on the whole a negative force because it breeds the politics of war and xenophobia.' For his part, Homi K. Bhabha argues that we cannot simply 'eliminate the concept of the nation altogether, at a time when in many parts of the world—in South Africa, in

Eastern Europe—people are actually living and dying for that form of society'.[8]

Contemporary South Africa does not have the integrated border often taken as the hallmark of nationhood. Even if it did, that border would still have mostly been drawn in by colonialism. And within our disintegral border(s) the material and symbolic conditions for the productive and effective exchange between even black and white so crucial for social transformation and reconstruction remain fragile. As South Africans we still share relatively little benign social space beyond the narrow corridors cast for us by hegemonic colonial histories. It was, after all, that great European Hegel who said 'Africa has no History.' For poet, critic and current head of the ANC's Department of Art and Culture, Mongane (Wally) Serote:

> We have [as a people] been denied our right to make culture and history as free people. Yet, as we struggle against oppression, and as we defend and fight for freedom, so we enter history, and as human beings we redefine and create culture.[9]

This re-entry has become part of an ongoing, increasingly differentiated and complex cultural struggle.

Rights of Passage?

Here I wish to engage with a very specific example where identity, tradition (history) and representation collided with unusual force. This occurred in a photographic exhibition held at the Market Gallery in downtown Johannesburg in November 1990. The exhibition was

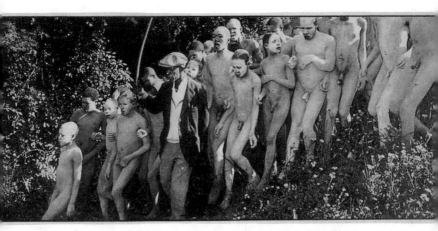

Steve Hilton-Barber, 'Magwella, the sangoma, and the initiates leave the bush to prepare for the final ceremony'

organised by the respected journal *Staffrider* and opened by none other than Barbara Masekela. The white photographer in question was Steven Hilton-Barber.

The exhibition generated a widely reported controversy. Deep feelings were aroused by the photographs on display, feelings which found their most open and disturbing expression in the angry, pained comments in the gallery's visitors book. A sample of these gives some idea of the depth of rage and confusion provoked by the exhibition of these images:

> Once again White Opportunist is on the rampage!! Exploiting and degrading blacks in the white media!

> Show us your own secrets of white women making love to dogs and forget our culture....Remember you are not an African...

> Go get fucked; you don't know what you are doing; expose your own foreskin with all the diseases...

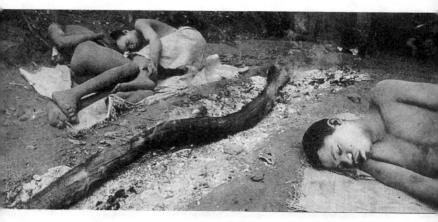

Steve Hilton-Barber, 'Exhausted initiates sleep during the day'

> You are a dog of no description go to hell. ... Rubbish
> red man you expose my culture...

Included too was this rather plaintive entry signed by a
local ANC member: 'Let us develop a culture of tolerance
and respect in the space that we have. The "remarks" in
the previous pages leave me extremely distressed.'

Resistance to the exhibition was consolidated when
some 47 employees of the Market Complex, including
well-known actor-director John Kani, signed a petition
headed by this statement:

> We ... hereby state our objection to the exhibition of
> photographs of the initiation ceremony of African
> males. We see it as an invasion of a sacred African tradi-
> tion, which has for centuries been private. We demand
> the removal of these photographs from public view.

Adding insult to injury these images appeared under the
rather predictable rubric 'rites of passage' in a mass-cir-
culation Sunday news magazine directed largely at the

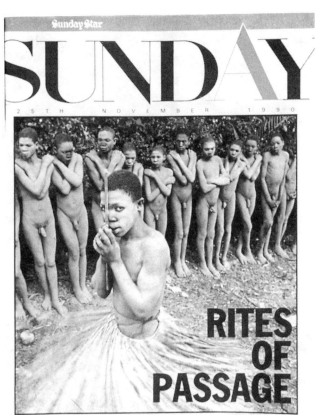

Sunday Star Magazine, 5 November 1990

white leisure market (*Sunday Star Magazine*, 25 November 1990). This publication coincided with the opening that Sunday. The exhibition was originally set to end on 18 January, but never made the New Year. It was closed when the photographs were stolen on 14 December. The captions were vandalised some three days later.

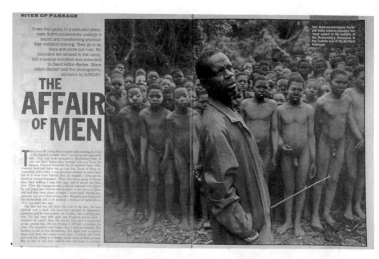

Every four years, in a secluded place, male Sotho adolescents undergo a secret and transforming process: their initiation training. They go in as boys and come out men. No outsiders are allowed in the camp, but a special invitation was extended to *David Hilton-Barber*. *Steve Hilton-Barber* took the photographs, exclusive to SUNDAY.

THE
AFFAIRS
OF MEN

Two hundred-and-twenty North-ern Sotho initiates attended this 'bush school' in the foothills of the Drakensberg Mountains in the Tzaneen area of the Northern Transvaal.

'The Affairs of Men', *Sunday Magazine* title page

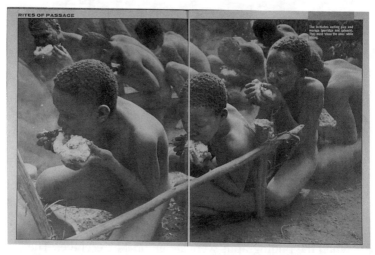

The initiates eating pap and maroga (porridge and spinach). They must 'close the anus' while eating.

'The initiates eating pap and maroga (porridge and spinach). They must "close the anus" while eating'

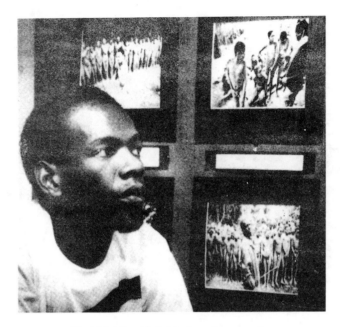

Vusi Ngidi with initiation photographs

The controversy was aired earlier in a public debate held at the Market Theatre on 12 December 1990.[10] The following, in summary (and at the risk of caricature), were among the main issues raised. All bear importantly on delicate and fundamental questions of identity, rights and accountability in the conflicted arena of cultural representation.

Violating Cultural Privacy

The photographs were held to be an invasive record of a ritual held sacred by a living community. This is obviously not a simple matter as the photographer Steve Hilton-Barber stated that permission to photograph the ceremony 'was granted by the principal of the school'.

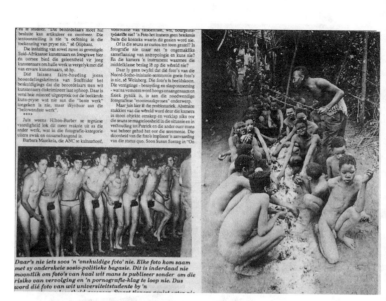

'Black initiates, white initiates', *Vrye Weekblad*

The only condition was, apparently, that he (Hilton-Barber) 'had been circumcised'. The latter also stated that both 'the initiates and the elders were aware of my presence and my purpose'.[11] In response Vusi Ngidi, spokesperson for the black workers at the Market Complex, argued that this was inadequate consultation, and that perhaps the broader community structures involved in matters of customary practices—such as the Congress of Traditional Leaders of South Africa—should have been consulted.

(Re)presenting 'Others' as Barbaric, Insensate, Objects

The photographs were perceived to objectify and debase their subject(s). Objectification is common, perhaps even

Circumcision photos stolen

GONE ... captions mark the spaces once occupied by the controversial photos

By HERMAN JANSEN

PHOTOGRAPHS of a Northern Sotho boys' initiation ceremony have disappeared from the walls of the Market Gallery in Johannesburg — a day after black gallery staff held a placard demonstration against them.

Exhibition organisers said yesterday they had reported the 20 photographs stolen but police said they had no knowledge of the theft.

The photographs by Steve Hilton-Barber disappeared during Friday night. The pins that held them in position had been neatly replaced.

Black gallery staff said the photographs showed disrespect for the Northern Sotho culture.

"The circumcision ceremony is sacred and not meant to be a public affair," said Vusi Ngidi, a spokesman for the workers.

Mr Hilton-Barber said he had never been approached directly by the workers to remove the pictures and had been granted permission by the initiation school to photograph the ceremony.

He said the theft of his photographs smacked of authoritarianism in that it was an arbitrary act of censorship.

Market Gallery curator Paula Beck was not available for comment last night.

'Circumcision photos stolen', *Sunday Times*, 16 December 1990

inevitable, in photographic practice. Here it readily crosses another powerful but dubious Western cultural tradition already mentioned in the context of exhibiting 'other' cultures, namely representing the contemporary 'other' as a dislocated, 'ahistorical' specimen—a primitive, timeless, and exotic oddity.[12]

Asserting Tribal or Ethnic Identity

An implied assertion of a tribal identity was felt to be especially problematic given the public, metropolitan setting of both the exhibition and dissemination of the photographs. As such the exhibition was considered misplaced and ill-timed given the broad political climate. Tribalism—as elaborated and entrenched by colonialism and Apartheid—has often been a divisive force in the larger quest for black national unity. The ongoing conflicts in the Inkatha-dominated regions in the province of Natal are arguably recent manifestations of this phenomenon. At any rate Vusi Ngidi called for a moratorium on such imagery:

> We are in a political crisis of transition, the pictures encourage tribalism....The social-minded artist should not work with tribalist images for now, it may be relevant, but the time is not right. Maybe in 10 or 20 years...[13]

Double Standards on Nudity

This involved intricate questions of pornography, sexism and racial mockery. The show was, for example, held to exploit racist attitudes towards nakedness. It might be remarked that this also routinely occurs in other realms of local visual culture. Showing bare-breasted 'traditional' women on tourist picture postcards is still, for example, widespread in South Africa. The same cannot be said for white women. Or, for that matter, as one report in fact pointed out, white boys undergoing initiation at a local Afrikaans-medium University.

Among the points sketched above the central issue which seems to underpin the whole controversy is at least

clear: who ultimately holds the rights to the appropria-
tion, representation and dissemination of cultural mater-
ial? The particular forms of production and publication
here (the art exhibition format, the leisure magazine, the
postcard) clearly beg fundamental questions of our
broader cultural practices often simply taken for granted.

Liberal addiction to some fantasy of absolute freedom
of expression suggests that anything may be appropriat-
ed, pictured and published. In South Africa this 'freedom'
seems, as elsewhere, largely conditioned by the needs of
the dominant cultural order.

Framing Subjection

The question of rights and responsibilities *is* undoubted-
ly a difficult one. In this exhibition the insistence on one
set of rights seems to have trampled others underfoot.
The right to cultural discretion, or even self™protection,
seemed on the face of it less paramount than the rights of
an arguably naive if well-intentioned, certainly well-
placed, individual photographer. We might be inclined,
depending on our own positioning, to take at face-value
and as sufficient Hilton-Barber's claim that he had
'attempted to act with integrity and with a sense of
responsibility and sincerity'.

Respected editor of *Staffrider*, Andries Oliphant, for
example, considered this controversy to be evidence of 'a
society where much still remains to be done before free-
dom of expression and the right to criticism become com-
mon values.'[14]

How might we make headway through this dense
thicket of questioning, contradiction and contestation?
Perhaps one way would be to address more carefully the

question of framing. Which evaluative frameworks might legitimately or even usefully be applied here? Could different frameworks actually or implicitly mobilised in the debates be reconciled?

The photographer himself was at pains, for instance, to insist that he was 'a documentary photographer and not a cultural anthropologist'. This seemed to suggest to him at least a different, perhaps conflicting, set of responsibilities. In asserting that the work be assessed on its quality as photography—'the standard of my photography'—the photographer also seems simultaneously to set both apart and elevate some autonomous aesthetic realm which takes precedence over all others. Yet criteria can obviously be derived from other realms, not least, for example, politically (self)conscious ethnographic practice.

As it stands we seem here to be caught up in what seems to be essentially consumerist behaviour, a behaviour largely shaped by the figure of the travelling aesthete or the aesthetic tourist. In this instance, that aesthete is a divided person. For Hilton-Barber is also at pains to introduce another dimension of value into our consumption—that of the document:

> It was my concern that this ritual should be documented, not only to add to the growing photographic cultural heritage of our country, but to help educate, enlighten and broaden understanding of different cultural practices.

The photographs thus also need to serve as some order of *evidence*, *facts* appropriated for the historical record. In some way this position embodies a perhaps unresolvable tension. Not only is aesthetic contemplation and its concomitant cultural status (as commonly understood) rarely

called for here, it may in fact undercut the documentary or evidentiary status of the work. John Tagg dramatises this tension elsewhere, when he suggests that the 'artist's proof is not the police officer's'.[15] I am reminded here of Walter Benjamin's comments on Atget's photographs of the depopulated streets of Paris. According to Benjamin these

> become standard evidence for historical occurrences, and acquire a hidden political significance. They demand a specific kind of approach; free-floating contemplation is not appropriate to them.[16]

Hilton-Barber was in fact quite insistent on this documentary function: 'My photographs are a factual documentation of a particular cultural practice and I attempted to record this ritual as accurately as possible.' He suggested in his response to the controversy that the vicissitudes of interpretation of this 'factual' record involved 'the question of perception', apparently *not* of the photographer, but of others. The implication seems to be that contextual and ethical ramifications lie effectively outside the responsibility of the photographer. (This implication was compounded when Hilton-Barber spoke of 'allowing the situation to speak for itself', or referred to the 'photographs themselves', or 'factual documentation'.)

Eric Margolis suggests that photographic

> evidence is persuasive and powerful ... photographs tend to overpower our critical faculties and our ability to question the image before us. Moreover, even in the case of documentary photography, there is always a tension between the requirements of artistic representation and the goal of accurate depiction.[17]

Later he comments more directly on the positioning of the taker of pictures. For Margolis the photographer

> cannot be other than a member of society, and is part of the photograph. The photographer's spatial and temporal location and access to subjects, their political perspective, social class, ethnicity, race, gender, attitudes and values circumscribe, define and determine what he or she will focus on. Moreover the photographer's presence is usually felt by the subjects.[18]

The photograph and the photographer are indeed powerful, and in this power, judgement and choice are unavoidable. Hilton-Barber himself acknowledged that one 'of the most enduring problems faced by documentary photographers is that of the distance between themselves and their subjects.'

This distance—and the judgement it necessarily occasions—becomes apparent when we consider this statement made by the photographer in the public debate; 'I attempted to document a *basically authoritarian* situation in a way that would allow the situation to speak for itself' (unpublished document, pp.5–6, my emphasis). Value-judgement is clearly implied when one characterises any situation as 'basically authoritarian'. This seems to have made Hilton-Barber or at least someone involved in the publication of his apologia nervous, as just these two words were dropped from the phrase in the *Staffrider* version.

In any event this implied transparency and value freedom—both in terms of documentary 'facts' (photographic 'evidence') and the absolute autonomy and exclusive relevance of aesthetic criteria ('good' photography)—face the challenge of being articulated through the actual power relations structuring the larger social domain in South

Africa. In a sense there is a conflict here between what John Tagg might call the honorific and the instrumental realms of representation. Referring to a specific photographic practice in the nineteenth century, Tagg writes of the 'privilege to be looked at and pictured' which he takes to be embodied in the first. In the second however:

> To be pictured ... was not an honour but a mark of subjugation: the stigma of an other place; the burden of a class of fetished Others—scrutinised, pathologised and trained, forced to show but not to speak, cut off from the powers and pleasures of producing and possessing meaning, fashioned and consumed in what Homi Bhabha has called a cycle of derision and desire.[19]

This larger political dimension comes into sharper focus if we invoke a more politically informed ethnological point of view. We might, for example, consider an exhibition at the Peabody Museum, Harvard University, held in 1986 and titled *From Site to Sight: Anthropology, Photography, and the Power of the Image*. Melissa Banta and Curtis Hinsley argued, in their sometimes rather tentative critical commentary on this exhibition, that:

> Intimacy always carries with it the burden of respect and responsibility ... and photographic intimacy, which involves the special exposure of human lives, adds a special need for sensitivity.[20]

This 'special exposure' is in fact played out in an interesting way in the image-text relation articulated in and by the captioning in the different contexts of display. Certain captions—captions which significantly condition, anchor, direct, even legislate the meaning of the image—altered with alterations in the context of display.

The first context was the exhibition at the Market Gallery, a second 'the Sunday magazine, a third the photographer's published response in *Staffrider*, a fourth the transformation of the photographs into postcards. Shifts in captioning across especially the first three contexts are worth noting here. In the exhibition, for example, one figure was captioned 'The initiates eating pap and maroga (porridge and spinach)'. In the rather more sensational *Sunday* magazine this caption was included within the image field with the addition of the words 'They must "close the anus" while eating.' When reproduced in *Staffrider* (after the controversy erupted) the caption was reduced to 'Eating'.

Striking too in the photographs accompanying the published apologia was the dropping of three images which show frontal nudity, including the image blazoned on the *Sunday* magazine cover. These omissions, with the editing out of the patently value-laden and provocative words mentioned above, suggest increased consciousness of and sensitivity to the power inscribed in this sort of photographic practice. We might finally take special heed of Banta and Hinsley's words in a chapter aptly titled 'The 'eyes that look back at us', so recalling the image on the *Sunday* magazine cover:

> In a fragile, politically splintered world, we need to see each other clearly ... photography wields more power than ever before and carries heavier ethical burdens. Because the ethical issues are not inherent in the technology itself but derive from its uses, the impact of photography depends less on the camera than on the person standing behind it. [21]

In their original publication and exhibition, these photographs were clearly felt by the workers to be a form of

symbolic violence. Certainly they could also be conceived as part of a process of epistemic violence. Loaded pictures, they came to represent, amongst other things, the myth (in the Barthesian sense of depoliticised speech)[22] of 'tribe' as wild-life, rendering the former 'fair' game for the dominant culture practising its peculiar pastime of semiotic trophy-hunting.

Conclusion

We still hear the echoes of the powerful voice of black activist Steve Biko. A major force in the development of Black Consciousness, Biko was murdered by the South African Security Police in September 1977. His promotion and celebration of black identity and self-possession ran counter to the divisive tribalist ethnocentricism so dear to the heart of Grand Apartheid.[23] Biko warned us not to 'underestimate the deeply embedded fear of the black man so prevalent in white society'.[24]

Could it be that the serpentine and unconscious workings of such fear may have motivated Hilton-Barber's practice in the first instance? Was it, more contentiously, the complex effects of just such fear which so inflamed response to Hilton-Barber's images?

Notes

1 hooks, bell, *Black Looks: Race and Representation*, Turnaround, London, 1992.
2 Mariani, Phil and Crary, Jonathan, 'In the Shadow of the West: Edward Said' *Discourses: Conversations in PostModern Art and Culture*, edited by Russell Ferguson, William Olander, Marcia Tucker and Karen Fiss, New York and Cambridge, Mass., New Museum of Contemporary Art and

MIT Press, 1990, pp.93–104.

3 Expressed in his address to the 'Culture and Development Conference', Johannesburg 25 April-1 May 1993. The word *ubuntu* (from the Nguni languages) is difficult to translate with any precision. Considered politically and philosophically it posits or gestures to a unifying, specifically African humanism which embraces notions of kindness, neighbourliness, and generosity. Matriarch Mama Ellen Kuzwayo says that in *ubuntu* 'a person is a person because of another person'. On a more precise but less affecting linguistic level it might be taken to mean 'humanity' or 'humanness'.

4 Albie Sachs, 'Preparing Ourselves for Freedom' and 'Afterword: The Taste of an Avocado Pear' in *Spring is Rebellious: Arguments about Cultural Freedom by Albie Sachs and Respondents*, edited by Ingrid de Kok and Karen Press, Cape Town, Buchu Books, 1990, p.146.

5 Albie Sachs, 'Kindling a Culture of Debate', *Mayibuye*, Vol. 1, No.2, September 1990, pp.42–5.

6 John Sharp, 'Ethnic Group and Nation: The Apartheid Vision in South Africa' in *South African Keywords: The Uses & Abuses of Political Concepts*, edited by Emile Boonzaier and John Sharp, Cape Town, David Philip, 1988, p.80.

7 E.J. Hobsbawm, *Nation and Nationalism Since 1780: Programme, Myth, Reality*, Cambridge, Cambridge University Press, 1990, p.163.

8 Homi Bhabha, 'Art and National Identity: A Critics Symposium', *Art in America*, Vol.79, No.9, pp.80–2.

9 Mongane Wally Serote, 'Post-Sharpeville Poetry: A Poet's View' in *On the Horizon*, Johannesburg, Congress of South African Writers, 1990, p.4. Serote is precise about dates. For him the 1987 CASA Conference in Amsterdam marked the people's wilful re-entry into their own historical narrative, a story of their own making.

10 Steven Hilton-Barber presented a response titled 'In Good Photographic Faith'. An edited version of this was later published under the same title in *Staffrider*, Vol.9, No.3, 1991, pp.34–9. Unless otherwise stated I quote from the published version.

11 Unpublished presentation, Market Panel Discussion, 12 December 1990, p.3. This was edited out of the published

version, where only the simple statement 'I had permission to photograph the ceremony and publish the photographs' remains. Tom O'Niell comments on this issue: 'Hilton-Barber emphasises the fact that he was given permission to be present only after he had shown himself to be qualified (i.e. circumcised). This can only mean one of two things. First is that he was insincere and was prepared to use trickery to gain access, in which case the whole argument is unnecessary as the ethics of the matter were disregarded right from the beginning. The other is that he was acknowledging the legitimacy of a tradition which considers it correct for this ceremony only to be known to qualified people. If this is the case, to subsequently expose this ceremony to the general (uncircumcised) public is an about face, and a breach of the contract implicitly made when he produced his own entry qualification. "Those Circumcision Photos: Arrogance or Ignorance"', *Staffrider*, Vol.9, No.4, 1991, pp.149–50.

12 Compare with Susan Sontag's discussion of Leni Riefenstahl's photographs of the 'nubians'. Sontag suggests Riefenstahl's work embraces and promotes a 'primitivist ideal: a portrait of a people subsisting in a pure harmony with their environment, untouched by "civilisation"'. 'Fascinating Fascism' in Susan Sontag, *Under the Sign of Saturn*, London, Writers and Readers Publishing Cooperative, 1983, p.86.

13 Quoted by Jonathan Rees, unpaginated draft report, Sapa, Johannesburg, 13 December 1990.

14 Andries Oliphant, 'Comment', *Staffrider*, Vol.9, No.3, 1991, p.1.

15 John Tagg, 'The Proof of the Picture' in *Grounds of Dispute: Art History, Cultural Politics and the Discursive Field*, London, Macmillan, 1992, p.99.

16 Walter Benjamin, 'The Work of Art in the Age of Mechanical Reproduction' in *Illuminations*, London, Fontana, 1973, p.228.

17 Eric Margolis, 'Mining Photographs: Unearthing the Meanings of Historical Photos', *Radical History Review*, No.40, p.35.

18 Ibid., p.40.

19 Tagg, op.cit., p.102. See also Killingray and Roberts, 'An

Outline History of Photography in Africa to ca. 1940', *History in Africa*, No.16, pp.197–208, argue that by the 1880s in Africa 'photography was being used more or less systematically by those engaged in the extension of colonial rule', p.200. They refer interestingly to the first coffee-table book 'of vanishing Africa' compiled by H.A. Bernatzik, where Bernatzik wrote that the 'natives are reduced to the position of slaves to the white colonisers....I have tried to preserve some pictures of a small fraction of this world that is fast disappearing....I always tried to take a photograph of natives when they did not notice it', p.203.

20 Banta, Melissa and Hinsley, Curtis M. *From Site to Sight: Anthropology, Photography and the Power of Imagery*, Cambridge Mass., Peabody Museum Press, 1986, p.125.

21 Ibid., p.127.

22 As Barthes wrote: 'in passing from history to nature, myth acts economically: it abolishes the complexity of human acts, it gives them the simplicity of essences...' 'The Photographic Message' in Roland Barthes, *Image, Music, Text*, New York, Hill and Wang, 1977, p.156.

23 In fact his own image, the image of his death, can be seen to be integral to a larger narrative within visual art during the decade of emergency.

24 Steve Biko, *I Write What I Like*, London, Bowerdean Press, 1978, p.77.

11
Two in One

HELEN CHADWICK

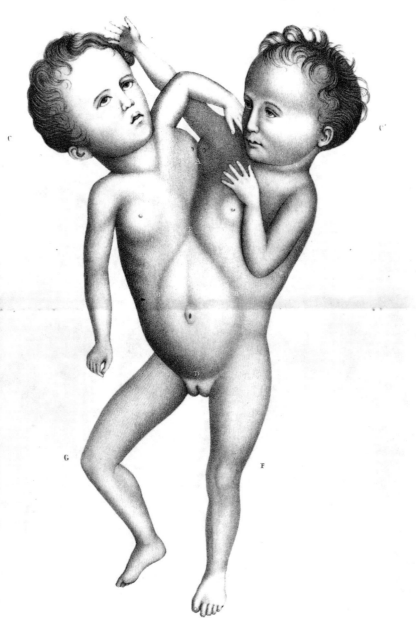

RITA CRISTINA

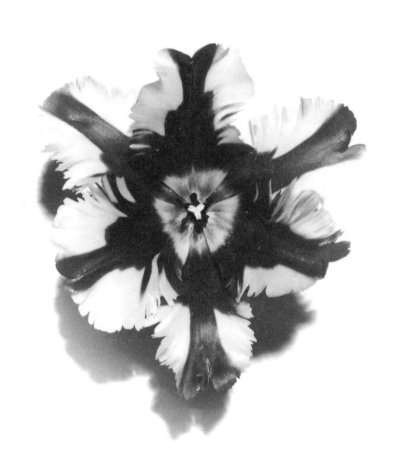

12

Signifying AIDS
'Global AIDS', Red Ribbons and
Other Controversies

SIMON WATNEY

How does one *see*, and hence think about an epidemic? Writing in the *New Yorker* in 1994, American journalist Stan Sesser noted of a recent trip to Japan that:

> A visitor to Tokyo quickly senses that something is missing. In two weeks of walking around the city's most crowded districts. ... I only once saw someone in a wheelchair. ... The disabled live in their own version of a world of apartheid—a world that gives an insight into that people with AIDS, a far worse stigma, are encountering?[1]

Conversely, some Japanese visitors to New York are doubtless struck by the vast army of variously disabled beggars who have nowhere but the streets and public spaces of the city in which to hang out. The experienced onlooker in New York will also be aware of the large numbers of emaciated women and men walking with sticks or being pushed in wheelchairs—everyday sights which one may easily come to take for granted in a city which has already experienced well over 50,000 diag-nosed cases of AIDS. Yet this says nothing of the many more tens of thousands living with HIV infection in New

York, or of the public and private institutions struggling to provide HIV/AIDS related care and services to those in need. Or of the more than 25,000 New Yorkers who have already died from AIDS, or of the vast and daily swelling army of the bereaved, many multiply bereaved, living through personal loss on a scale unparalleled outside of wartime experience.[2]

Behind the cumulative totals of AIDS cases in different cities and different countries and regions there are clear variations in social groups which have been affected worst by HIV, and which are at greatest risk. It is by now well established that needle-exchange facilities and appropriate ancillary services can play a dramatic role in reducing the rate of new HIV infections amongst injecting drug users and, by extension, their sexual partners. Wherever HIV/AIDS continue to proliferate amongst injecting drug users, this is invariably associated with the absence of such demonstrably effective prevention programmes. Prevention work amongst gay men varies greatly in quantity and quality around the world, with consequences that may be measured in terms of rising rates of new HIV infections (where these are recorded and published). Furthermore, the size of national epidemics is affected by contingent standards of health care provision, and so on. Thus there is no simple 'AIDS epidemic'. Rather, in the thirteen years since the identification of Acquired Immune Deficiency Syndrome, the local, national and international faces of AIDS have been intimately shaped by many social and political variables. In other words, policies set by governments and other agencies have played a major role in determining the present distribution of HIV and AIDS within specific population groups around the world. AIDS is not simply 'a natural phenomenon'. Where effective, grass-roots community-

based HIV / AIDS prevention and education programmes have been established, their impact has been felt. Where such initiatives have either been neglected or, as is often the case, where they have been *prevented*, this is equally reflected in local levels of sero-prevalence.

Thus one may find markedly different levels of HIV infection in closely adjacent cities of comparable size such as Glasgow and Edinburgh. The greater prevalence of HIV amongst injecting drug users in Edinburgh sadly reflects prevailing punitive police policies in that city in the late 1970s and 1980s.[3] Indeed, one can only really understand the AIDS crisis from studying the evolving statistics of HIV infection, AIDS diagnoses and AIDS mortalities, considered locally, nationally, regionally and internationally. Yet it is precisely this understanding which most public representations of the epidemic seem to efface or obscure, by over-simplifying and over-generalising. Thus by casual and repeated reference to 'the global epidemic' or 'AIDS in Europe', the most important specific features of HIV/AIDS are totally abstracted and erased. This is most obviously the case in reports about the cumulative totals of AIDS cases in different parts of the world, for such totals tell us nothing whatsoever about current rates of net HIV infections, or which types of HIV transmission predominate locally or even nationally. It should be frankly understood that the primary existence of the epidemic is at this initial epidemiological level of the rates of distribution of HIV and AIDS—rates which may change slowly or fast, for the better or for the worse, in relation to the availability or neglect of effective prevention and education campaigns.

Yet for many years, much public discourse on AIDS has been dominated by a 'globalist' approach which only rarely troubles itself with the clarification of exactly how

HIV continues to have different impacts, according to different modes of transmission, in different countries, and different degrees of human intervention. In many countries, the needs of entire 'at risk' populations have been but entirely disregarded by national governments of all political persuasions. In all of this, worldwide, the needs of gay and bisexual men have been most consistently and systematically ignored, with terrible, predictable consequences in terms of HIV transmission, illness and death, and the often invisible related suffering throughout the international diaspora of gay identities. In American cities such as New York it seems likely that at least 50 per cent of all gay men are already infected, whilst in Britain it is estimated that perhaps one in twenty gay men are already HIV positive, rising to one in five taking the HIV antibody test at some central London GUM clinics.[4] Yet in Britain, as in most other countries, HIV/AIDS education for gay and bisexual men has only received a tiny percentage of the total funding for prevention and education, even though we continue to make up 76 per cent of the annual death rate from AIDS. This is not 'special pleading', but the plain epidemiological reality.

World AIDS Day

Since 1988, the World Health Organisation (WHO) has designated 1 December as World AIDS Day, each year it is organised around a different theme. Thus in 1994, World AIDS Day highlighted 'AIDS and the Family', following the United Nations proclamation of 1994 as International Year of the Family. In 1993 the theme was 'Time to Act', specified in publicity materials as: 'a day of action designed to raise public awareness of HIV and AIDS'.[5]

Yet as Edward King has pointed out:

> That was 1993, twelve long years and hundreds of thousands of deaths since AIDS was first recognised. Those on the front lines had been acting for years, actually, and often in the face of inaction or obstruction from the public health system. What a nerve for that same public health system now to turn round and declare that it was finally Time to Act! Thanks for nothing. I can't even bring myself to say better late than never.[6]

World AIDS Day publicity materials typically consist of masses of abstract data, and pious declarations against 'denial', 'prejudice', and so on. But denial *of what*, and *by whom*? An 'educational' quiz included in the 1993 materials produced by the London Borough of Camden Social Services Department asks if five statements are true or false:

1. Women are safe from HIV as long as they use a contraceptive.

2. You can get HIV from wooden toilet seats, but not plastic ones.

3. Injecting drug use will give you HIV.

4. HIV only affects certain groups in our community.

5. You can get free condoms from family planning clinics.[7]

The officially 'correct' answers to these questions tell us much about the ways in which World AIDS Day encourages us to think about the epidemic. Thus the answer to question 1. is 'false', since 'condoms offer protection against HIV and pregnancy, but other contraceptives only

offer protection against pregnancy'. In this manner a simple message about condoms is confused with questions of pregnancy and other means of contraception—hardly relevant to local gay and bisexual men, who made up no fewer than 90 per cent of new cases of HIV in Camden in 1993/94, and 90 per cent of newly diagnosed AIDS cases in the same period. Question 2 is also 'false', but a ridiculous distraction from the central issues, since in neither case is anybody at any risk whatsoever. Question 3 is also 'false' which is reassuring, since injecting drug use is so frequently understood to be intrinsically a risk for HIV, rather than the practice of sharing needles. The official answer to question 4 is also 'false', since, we learn, 'HIV can and does affect people from all sections of the community'. In this manner the prevailing 'equal opportunities' approach to AIDS obscures the fact that all along HIV has been *overwhelmingly* concentrated amongst gay and bisexual men, and injecting drug users and their sexual partners. Yet this is apparently not an officially acceptable 'fact'. Question 5 is, happily, 'true'.

The National AIDS Trust leaflet for 1994 World AIDS Day informs us that in Britain, as of March 1994: 'at least 21,718 people had contracted HIV. Of these people, 9,025 had developed AIDS, of whom 6,031 had already died.'[8] Such information is little more than strategic disinformation as it fails to make plain that 13,134 of the HIV cases were amongst gay and bisexual men, the second largest group of 1,770 cases being men infected by sexual partners abroad, or as it fails to establish that 6,792 of the UK total of 9,025 AIDS cases were again amongst gay and bisexual men, followed by 588 men infected by unprotected sex with HIV positive women.[9]

Rather than clearly establishing the similarities and differences between the experience of, and responses to

HIV/AIDS in different parts of the world, the ideology of World AIDS Day sets up a fictive unity in the name of 'the global', as if HIV/AIDS were everywhere the same. The concept of 'Global AIDS' was originally elaborated in a series of documents produced by the Global Programme on AIDS, within the World Health Organisation in the second part of the 1980s.[10] In essence it has four major characteristics. First, it takes the regional as its fundamental category of priority for thinking about HIV/AIDS. Second, it is extremely homophobic, as much in its silences and omissions as in anything explicitly stated. Third, it mobilises a generalised neo-liberal discourse against 'discrimination', with frequent appeals to notions of common 'humanity' and so on. Fourth, it derives directly from a generalist tradition of public health policy-making which is primarily concerned with *total* healthcare provision. Its cultural manifestations are usually couched in terms of vague notions of 'compassion', 'tolerance' and 'solidarity'.

But solidarity *with* and *between* whom? And who is 'tolerating' whom? For example, it is far from clear that prejudice against injecting drug users is globally uniform, or related in any significant way to homophobia, misogyny or racism. AIDS does not simply cause an abstract cloud of generalised 'prejudice'. Rather, it mobilises deep cultural forces which may vary greatly within and among different nations. Of course one needs to understand the regional patterns in order to encourage and to organise adequate national and international responses. Yet it frequently seems that in reality, the World Health Organisation has imposed an extremely restrictive model of the epidemic at the heart of its Global AIDS Programme, which specifically refuses to acknowledge the urgent needs of gay men around the world,

including those whose identities are formed in other traditions of sexuality. Solidarity is urged with the interests of prostitutes and injecting drug users, especially in so far as they are tacitly deemed responsible for the 'spread' of AIDS into what is imagined as a global heterosexual population, but never with gay and bisexual men. Whilst it is doubtless diplomatically necessary that World Health Organisation agencies work with governments which have very different track records on human rights issues, especially in relation to homosexuality, it seems that the Global Programme's response has simply been to ignore gay men's needs altogether, whether in the developed or the developing worlds.[11] In this context the rousing triumphalism of a vision of 'global solidarity' around such issues as the United Nations, nuclear war, and AIDS, as 'one of the glories of our era' rings rather hollow.[12] In a nutshell, for 'global' read 'heterosexual transmission'.

Translated into local British terms, and duplicated more or less exactly throughout the developed world, World AIDS Day is described as

> an annual day of observance designed to expand and strengthen the worldwide effort to stop the spread of HIV and AIDS. Its goal is to open channels of communication, promote the exchange of information and experience, and forge a spirit of social tolerance.[13]

In Britain, World AIDS Day is coordinated by the National AIDS Trust whose 1994 publicity materials explain the significance of the theme of AIDS and the Family, noting that:

> Each nation must tailor the theme to reflect its own situation and pattern of epidemic. This is ever more true at local level. Unlike many countries in the world, the

> UK epidemic mainly affects men who have sex with
> men. Although families are of course affected, often as
> carers.[14]

Yet equally one might say that the UK epidemic is also
extremely like that in many other countries, but this
would not fit with the overall heterosexual bias of Global
AIDS-speak. It is also notable that we only learn of
abstracted 'men who have sex with men'. Has anyone
ever existed who thinks of himself in such terms—for
example, 'Hello, I'm a Man Who Has Sex With Men'?
Most striking of all is the sense of an almost biological
divide between 'families' and these 'men who have sex
with men', as if gay men were not as fundamentally a part
of families as anyone and everyone else. It seems that
families can 'care' for us (assuming that we are HIV posi-
tive), and that is our only permissable relationship to
them, conveniently dying.

'Highlights' of World AIDS Day 1994 in London in-
cluded:

> A candlelight vigil on the South Bank outside the
> National) Theatre at 6.00 pm on December 1st for 45
> minutes organised by the National AIDS Trust.
> Leading actors and actresses including Sir Anthony
> Hopkins, Dame Judi Dench and Helen Mirren, and
> opera diva Lesley Garret have been approached to
> read out names of those who have died from AIDS. A
> 120-strong all-girl school choir will sing music by
> Vaughan Williams.
>
> The second Concert of Hope at Wembley Arena ...
> organised once again by George Michael, with
> Princess Diana, patron of the National AIDS Trust, as
> the guest of honour.[15]

Yet why hold a vigil outside the National Theatre, an

institution which exercises neither power nor authority in public AIDS policy-making or practice? And whilst it is of course heartening that celebrities are prepared to take part in such ceremonies, it is far from clear what exactly they are intended to signify. If AIDS deaths are special from other deaths, it is because of objective factors of neglect, legal discrimination, the censorship of health promotion materials, government cuts in voluntary sector funding, mismanagement, and so on. The best intentions are evidently being mobilised but to no clear purpose. For example, whilst it is also heartening that massive fundraising concerts can be organised and broadcast, it is never specified *why* such funding is necessary in the first place, or to what agencies funds will be directed, or on what criteria.

Furthermore, the overwhelming heterosexual bias of the working ideology of 'Global AIDS' ensures that some of the most glaring examples of the effects of racism are never discussed. For example, HIV has had a vastly disproportionate impact amongst American black gay and bisexual men, in direct relation to the all but total official neglect of their entitlements to HIV/AIDS education.[16] The Global AIDS Programme frequently extols the virtues of community-based HIV/AIDS education and services, but this is more in recognition of the unlikelihood of most governments responding well to any aspects of human sexuality, rather than from a recognition of the needs of those who are doubly neglected as the direct result of racism combined with homophobia. For HIV is decidedly not an 'Equal Opportunities' virus. It does *not* affect everybody equally, and least of all does it do so at the global level. Commenting on the 1992 World AIDS Day theme of 'A Community Commitment', Edward King pointedly invites us

to guess which community was mysteriously missing from the WHO's official list of communities, which included lots of non-communities or pseudo-communities such as social clubs or geographically defined communities. ... Yup, you guessed who was missing?[17]

Plus ça change.

Red Ribbons

Since 1992, British World AIDS Day materials have come heavily draped with the image of red ribbons, described by the National AIDS Trust as 'an international symbol of concern about AIDS'.[17] In 1992, the NAT offered some 'ideas on opportunities and uses for red ribbons'. These included advice to:

Get your family/friends/colleagues/people you meet on the bus to wear one. Wear one yourself!!!

Order enough for your employees to wear them.

Hang big ones out of your window.

Tie them on your windscreen wiper or bumper.

Tie one around your portable phone/fax/computer/notepad.

Put one on your pet's collar.

Give them out in shopping precincts.

Tie them around parking meters, fence posts, railings, etc.

Use them in foyer displays.

Do something far too outrageous to mention in print.[18]

Such gushing nonsense tells us much about the enthusiasm with which Red Ribbonism has been adopted in the UK. The familiar image of a red ribbon signifying 'AIDS awareness' goes back to the work of New York artists, curators, critics and others who formed themselves into a group called Visual AIDS in 1988. Visual AIDS met informally at first, with monthly meetings, out of which various cultural projects emerged, including the Witness Project, and a slide archive of AIDS-related artworks, housed at the Artists' Space in New York. In response to the US Vietnam Memorial Day in 1989, Visual AIDS developed the now widely adopted Day Without Art, when American museums annually align themselves with the AIDS crisis with specially curated exhibitions, the closing off of galleries for a day, the temporary display of paintings with their fronts to the wall, and so on.

In the early spring of 1991, the United States was at the height of the Gulf War and awash with media-fuelled jingoism, often expressed by yellow ribbons, emblematic of US nationalism. In response, Visual AIDS adopted red ribbons, understood as a public art-work, aiming to draw attention to the under-funding of HIV/AIDS services, by contrast to the lavish cost of the military defence of Kuwait. Visual AIDS Director Patrick J. O'Connell insists that the Red Ribbon Project was not designed 'to point fingers at who didn't do what', but aimed instead to draw attention to AIDS 'as a national issue'.[19] Whilst the sale of red ribbons in bulk has raised much needed cash for US AIDS charities, its level of semiotic generalisation has also been widely criticised. American gay writer John Weir for example argues that: 'People who are truly living with or dying of AIDS or caring for sick lovers or friends don't need gentle reminders about their situation'.[20]

Yet this does not of course include the great majority of

Americans or Britons. Furthermore, the significance of ribbons will change in different local contexts. After tennis star Pete Sampras and others wore red ribbons at Wimbledon in July 1993, journalist Peter Bond complained in London's *Evening Standard* that:

> Gay campaign fanatics are harassing stars and sports heroes into appearing on TV with an AIDS red-ribbon emblem pinned on their clothes, it is claimed. The symbol is supposedly a 'pride badge' showing that the wearer is sympathetic to those suffering from the disease. But the A-shaped motif has a less innocent aim: representing gay unity manipulating public opinion towards homosexuality ... many celebrities are being coerced by *threats* into displaying the emblem in front of the cameras with gay bully boys in Britain as well as in America saying: 'We'll make your lives misery if you don't'. ... Ian Hislop of BBC2's *Have I Got News For You*, says: 'It makes me so annoyed. At the BAFTA dinner, there was a ribbon waiting on each plate. I refused to put mine on.'[21]

A week earlier the *Sunday Express* had roundly castigated the wearing of red ribbons, claiming that:

> This fashionable obsession with AIDS is more than offensive, it's actually dangerous. It deflects attention from other, more urgent, causes.[22]

Predictably, Ian Hislop, the editor of *Private Eye*, also turned up in the *Mail On Sunday*, again repeating the tale of his shocking intimidation at the BAFTA dinner earlier in the year:

> Having just lost a close relative to a disease that is equally incurable, though much less fashionable, I decided not to conform. If I felt like making a point

about leukaemia for example, could I wear an L shape on my lapel in order to let everyone know?'[23]

Such frivolous comparisons between HIV and other, non-infectious, uncontroversial illnesses only serve to demonstrate how little journalists such as Hislop understand about AIDS. If leukaemia were preventable, and if prevention measures were routinely neglected, and if people living with leukaemia were discriminated against in law, then and only then might the analogy with AIDS be relevant. It is however significant that other patient-groups, including women with breast cancer, have developed parallel 'ribbon projects', which aim to associate other colours with other diseases and other medical conditions. This proliferation of 'disease-symbols' cannot articulate shared needs or goals, because each symbolised disease is placed in relations of potential *rivalry* to every other symbolised disease—for funding, research, media attention, etc.

Hislop also complained in the *Mail on Sunday* that 'AIDS charities dominate media events and on these occasions the red ribbon has become de rigueur',[24] a comment significantly echoed in Simon Garfield's account of the history of red ribbons, in which he reports that within months of the 1991 Tony awards, red ribbons were 'de rigueur at every awards ceremony, every tribute'.[25] This is history rewritten from the venomous perspective of old press clippings rather than direct research, which would demonstrate how very few celebrities in Britain or the USA have ever in any way associated themselves with HIV/AIDS issues, even at the highly abstracted level of red ribbons.

It is however undoubtedly the case that the manufacture and marketing of the red ribbon motif has had decidedly distasteful aspects. For example, for several years the

American West Coast gay magazine *The Advocate* has carried advertisements for commodities such as a transparent lucite paperweight containing a 'hand embedded ribbon'—a snip at $25 + $4 for shipping, handling and sales tax. One may also purchase a 4″ x 11″ table sculpture, inscribed underneath (conveniently out of sight?): 'To All Those who May Have, Cared For, Or Have Been Touched By AIDS'. This 'beautiful glass art piece' as it is described in the advertising blurb, supposedly

> symbolizes the need for awareness and offers a tribute to the broken hearts and the tears that have been shed due to the AIDS crisis. Excellent for the home or office to provide a visual representation of the need for awareness, compassion and remembrance. Allows each of us the opportunity to engage friends and family in conversation about AIDS and to educate those around us.

'Compassion' could be yours for a mere $149 + $4.95 for shipping and handling.

Meanwhile in Britain in 1992 a private businessman, Andrew Butterfield, had set up a charity named Red Ribbon International to make and distribute red ribbons. Butterfield was displeased with the way in which the National AIDS Trust had set a red ribbon within a triangle as its 1992 World AIDS Day logo, and complained of: 'the ease with which it could be associated with the gay Pink Triangle, once again marginalising the AIDS issue which the Red Ribbon is breaking away from'.[26] In other words, to the man who controlled the marketing of red ribbons in Britain until 1994, AIDS is an issue which must be protected at all costs from the taint and guilt by association of any connections with gay men[27]. So much for the gay 'fanatics' and 'bully boys' supposedly conspiring to

convert Britain to wholesale sodomy through the sporting of red ribbons, according to the UK popular press.

This type of apparent profiteering has no simple or inevitable reputation to the meanings people associate with red ribbons, least of all on the part of those who wear them. For the red ribbon has indeed achieved its own measure of success, at least in the numbers of people seen wearing them every day in London and the larger cities of the UK. We cannot possibly know precisely why people choose to wear red ribbons, but in a recent random sample consisting of the first five people I came across wearing ribbons one chilly morning in south London in late November 1994, one was a young female nurse working on an AIDS ward, two were young women who explained they had gay friends with HIV, one was a young gay man, and one a middle-aged gay man. All expressed versions of the belief that AIDS is a public issue with which they identified. The young gay man said he thought the red ribbon more important than Armistice Day poppies, 'because people are dying unnecessarily now'. This view may be typical, or exceptional. In either event, red ribbons are widely worn with the best of intentions, even if these may seem woolly and vague to the better informed, who can hardly be expected to think of red ribbons as much more than a distraction, more or less irritating or heart-warming according to mood. And indeed it was moving to see Martina Navratilova and all the other 1994 Wimbledon finalists wearing red ribbons before such a vast television audience. Red ribbons may not say enough, but they say something, and it is up to us to articulate the fundamental issues at stake in the AIDS crisis in such a way that this is unambiguously what red ribbons will come to mean for those who select to wear them. Rather than blaming red ribbons for not explaining everything that by now ought to be more widely under-

stood about HIV/AIDS, we should strive to make public discussion of HIV/AIDS clearer and better informed. Let's campaign to make red ribbons indeed emblematic of injustice in the AIDS crisis, whether that involves the neglect of gay men's needs in the UK, or the neglect of injecting drug users elsewhere in much of Europe and the United States.

After all, there have been terrible losses, and for many these require public and private signification, for personal emotional reasons as much as for any other more overtly political or educational purposes. Inadequate as it may often seem, red ribbons do in part testify to the scale of our losses, and constitute a cultural revival of public forms of mourning, affirming the importance of those who were rarely valued in their lifetimes, whose deaths remain almost entirely unregretted in the public discourse of the mass media and the other leading institutions of public life throughout the world. This is however a genuinely global issue to which it remains unlikely in the extreme that the World Health Organisation will ever turn its attention, and least of all on any future World AIDS Day.

Notes

1 Stan Sesser, 'Letter From Japan: Hidden Death', *The New Yorker*, 14 November 1994, p.63.
2 See Simon Watney, 'Acts Of Memory', *Out*, New York, September 1994, pp.92-7.
3 See Simon Garfield, *The End of Innocence: Britain in the Age of AIDS*, London, Faber & Faber Limited, 1994, Ch.5.
4 See Edward King, *Safety in Numbers: Safer Sex and Gay Men*, London, Cassell, 1993; New York, Routledge, 1994, Ch.1.
5 WAD 93, Press Pack, National AIDS Trust, London.
6 Edward King, 'Whose life is it anyway?', London, *Pink Paper*, Issue 355, 25 November 1994, p.16.
7 Camden Social Services, London, *World AIDS Day*,

December 1993, p.2.

8 National AIDS Trust, *World AIDS Day: 1 December 1994*.

9 Public Health Laboratory Service, London, *Quarterly AIDS and HIV Figures*, 94/1, 25 April 1994.

10 For example, Jonathan Mann, Geneva, *Global AIDS: Into the 1990s*, World Health Organisation, 1989, GPA/DIR/89.2.

11 I am not aware of a single WHO document which specifies the needs of gay men, though we continue to make up the greater number of HIV and AIDS cases in many parts of the world.The Panos Institute in London is currently undertaking an initial survey of gay men's needs in the developing world, the first of its kind.

12 Mann, *Global AIDS*, p.7.

13 National AIDS Trust, Resource Pack, London, 1 December 1994.

14 Ibid.

15 'World AIDS Day', *Gay Times*, London, November 1994, p.44.

16 *HIV/AIDS Surveillance Report*, CDC, Atlanta, Georgia, USA, Vol.6, No.1, 1994, p.22.

17 Edward King, 'Comment: World AIDS Day', *Pink Paper*, Issue 335.

18 National AIDS Trust, London, *WAD 92, World AIDS Day Newsletter*, Second Issue, October 1992, p.2.

19 Personal communication.

20 John Weir, 'The Red Plague: Do Red Ribbons Really Help in the Fight Against AIDS?', *The Advocate*, Los Angeles, Issue 628, 4 May 1993, p.38.

21 Peter Bond, 'AIDS bully boys' star symbol is so sinister', *Evening Standard*, London, 12 July 1993, n.p.

22 *Sunday Express*, 4 July 1993, n.p.

23 Sharon Churcher, 'The tyranny of the AIDS pride badge', *Mail On Sunday*, London, 11 July 1993, n.p.

24 Ibid.

25 Simon Garfield, *The End of Innocence*, p.255.

26 Ibid., p.259.

27 At a later date, Butterfield attempted to obtain trade mark protection both for red ribbons and the phrase 'AIDS Awareness' and by so doing lost any support he may still have enjoyed within the larger agencies that had previously funded his company.

List of Contributors

Neal Ascherson has worked as a journalist and foreign correspondent for the *Guardian*, the *Scotsman* and the *Observer*. His books include *The Polish August*, 1981, *The Struggles for Poland*, 1987 and *Games with Shadows*, 1988. He is deputy editor of the *Independent on Sunday*.

Pavel Büchler is an artist, co-founder of the Cambridge Darkroom, and currently Head of Fine Art at the Glasgow School of Art.

Helen Chadwick, artist, is known for work concerned with the cultural perceptions of sexuality, gender and the body. Her work has been exhibited widely, most recently in a solo retrospective at the Serpentine Gallery, London, in July 1994.

Stan Douglas, artist, works with film, video and broadcast television. His installation *Hors-champs* was first shown at Documenta, Kassel, in 1992.

Terry Eagleton, the Warton Professor of English at St Catherine's, Oxford, is the author of, among others, *The*

Ideology of the Aesthetic, Marxism and Literary Criticism, Walter Benjamin and *Saints and Scholars*. A version of 'Crisis of Contemporary Culture' was first published by Oxford University Press in 1993.

Susan Hiller is an artist whose work in a range of media is widely exhibited. A collection of her talks and interviews entitled *Thinking about Art: Conversations with Susan Hiller*, is forthcoming from Manchester University Press. *Belshazzar's Feast* was screened on Channel 4 and is in the collection of the Tate Gallery, London.

Ian Hunt is a writer, critic, editor and publisher. His previous work on Walter Benjamin has been published in the contemporary art review *Frieze*.

Colin McArthur, writer and film critic, is Director of the Centre for Scottish Popular Culture at Queen Margaret College, Edinburgh. His writings on television and cinema include *Dialectic! Left Criticism from Tribune*, 1982, *Scotch Reels*, 1982, and *The Big Heat*, 1992. His book *The Casablanca File* was published by Half Brick Images in 1992.

Nikos Papastergiadis, former co-editor of *Third Text*, is a lecturer in Sociology at the University of Manchester. He is the author of *Modernity as Exile*, 1993, and, most recently, *The Complicities of Culture: Hybridity and 'New Internationalism'*, Cornerhouse, Manchester, 1994.

Colin Richards lectures in the Department of Fine Arts, University of the Witswatersrand, South Africa. An earlier version of his paper 'Whose Subject? Moments of identity and conflict in South African visual culture' was

published in *Third Text*, Nos. 16–17, Autumn/Winter 1991.

Peter Sloterdijk is Professor of Philosophy at the Academy of Art and Design in Karlsrue and a visiting professor at the universities of Vienna and Frankfurt. He is the author of several books including *Eutotaoismus* and a novel on the beginnings of psychoanalysis, *Der Zauberbaum*. His *Critique of Cynical Reason* was published by Verso in 1987.

John Stezaker, artist, lectures in History of Art at the Royal College, London. His photo-based works and collages have been exhibited and published widely since the early 1970s, recently, among others, at Salama-Caro Gallery, London, and in Flora Photographica in Montreal.

Simon Watney is a critic, art historian, media analyst, activist, teacher and a director of the Red Hot AIDS Charitable Trust. His books include *Policing Desire*, *Taking Liberties* and *Practices of Freedom*, published by Rivers Oram Press in 1994.

Richard Wentworth, artist, is a recent recipient of the DAAD scholarship resulting in two exhibitions in Berlin, 1994. A book of his photographs *Berlin: 127 Landmarks* was published by the DAAD in 1994.

Acknowledgments

Many individuals and private and public institutions have given invaluable help in organising and realising the Friday Events series on which this book was based. Thanks are particularly due to the Glasgow Film Theatre, Glasgow School of Art Student Representatives Council, Herr Joachim Buhler and the Goethe Institut, Glasgow, Transmission Gallery, and Stereo Stereo, Glasgow.

Terry Eagleton's paper is based on a lecture delivered at St Catherine's College, Oxford, 1992, and is published here with the permission of Oxford University Press. The licence to reproduce Mirò's *Ceci est la couleur de mes rêves*, 1925, and Giacometti's *The Dream, the Sphinx and the Death of Mr T*, in Susan Hiller's contribution, has been granted by ADAGP, Paris, and DACS, London, 1994; Dürer's *The Nightmare* is reproduced by permission of the Kunsthistorisches Museum, Vienna; all other illustrations are taken from David Coxhead and Susan Hiller, *Dreams: Visions of the Night*, Thames and Hudson, London, 1976, and reprinted with the authors' permission. The film stills accompanying Colin McArthur's essay are reproduced, by permission, from the author's book *The Casablanca File*, Half Brick Images, London, 1992, and from his archives. The photographs in Colin Richards's article are used by permission of South Africa's *Sunday Star*, *Sunday Times*, and *Vrye Weekblad*.